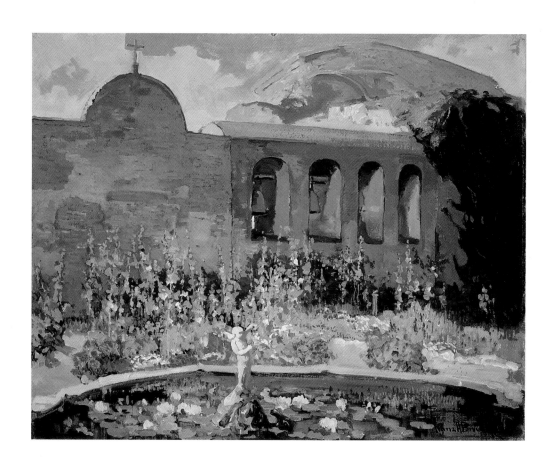

Romance *of the* Bells

the

California

Missions

in Art

The Irvine Museum

JEAN STERN *Executive Director, The Irvine Museum*

GERALD J. MILLER *Administrator, Mission San Juan Capistrano*

PAMELA HALLAN-GIBSON NORMAN NEUERBURG

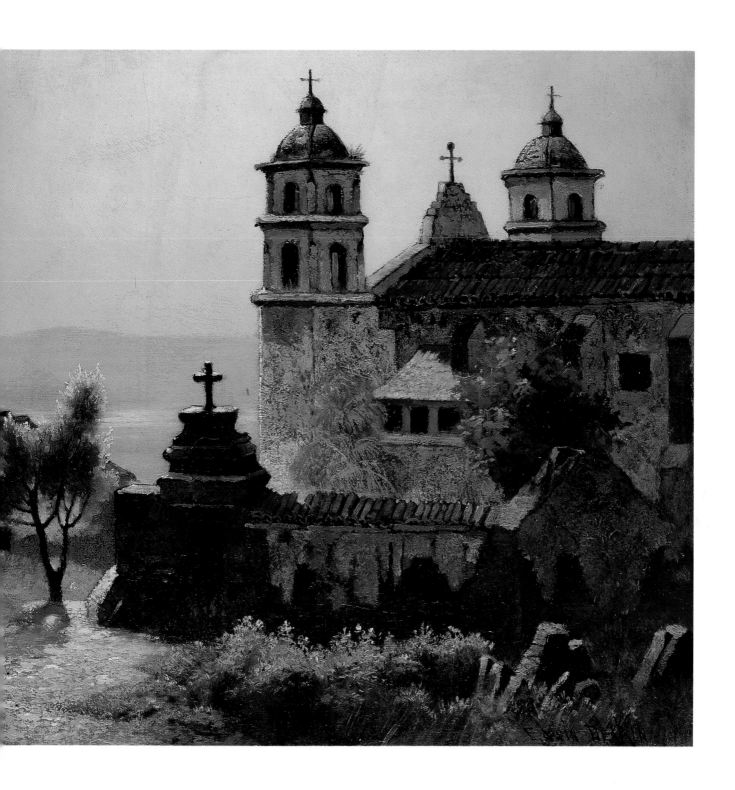

This book was published on the occasion of a joint
exhibition at the Mission San Juan Capistrano
and The Irvine Museum, 17 June–14 October 1995.

Library of Congress Catalogue No. 95-076027
ISBN 0-9635468-5-6 (cloth)
ISBN 0-9635468-6-4 (paper)
Printed in Hong Kong

Cover: Alson S. Clark, *Mission Cloisters,
San Juan Capistrano*, 1921, oil on canvas, 36 x 46 inches.

Page 1: Franz A. Bischoff, *San Juan Capistrano
Mission Yard*, oil on canvas, 24 x 30 inches.

Frontispiece: Edwin Deakin, *Santa Barbara Mission*,
oil on canvas, 12 x 18 inches,
Dr. & Mrs. Edward H. Boseker.

Table of Contents

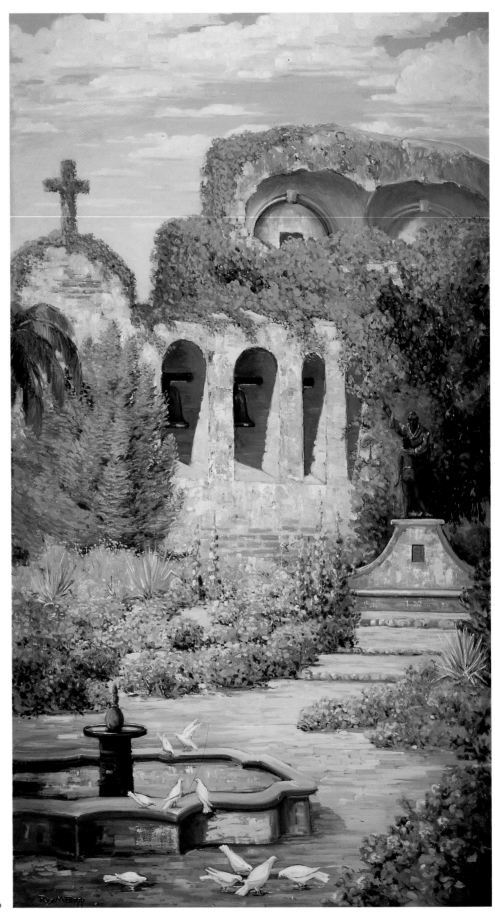

Roy Ropp
Capistrano Mission
Oil on canvas
60 x 33 inches
Mission San Juan Capistrano

Introduction *by Joan Irvine Smith*

It is a great pleasure to present this distinguished collection of paintings of the California missions as a joint endeavor of the Mission San Juan Capistrano and The Irvine Museum. The Capistrano mission is one of the oldest buildings in California, and I have always had a great affection for this historical treasure. When I was a small child, my mother and my grandmother would take me on Sunday drives from our home in Los Angeles to visit the mission in San Juan Capistrano. I recall those visits among the highlights of my childhood. In those days, the mission grounds were covered with colorful flowers, a sight that is captured in many of the paintings in this book. I remember how I always loved to feed the great flock of white pigeons that fluttered about the fountain in the courtyard and along the garden paths. Over the years, on countless occasions, I have delighted in taking both family and friends to visit the historic buildings and beautiful grounds, and to my great enjoyment have watched my own grandchildren feed the gray pigeons that are found at the mission today.

The Capistrano mission represents an important part of the history of Southern California, and I believe it should be preserved and restored for the benefit of generations to come. The history of California is also recorded in the art which has been inspired by the mission. As you may know, my interest in California impressionist paintings, dating from 1890 to 1930, led to the founding of The Irvine Museum in 1992, with its Grand Opening in January of 1993. The Mission San Juan Capistrano is undoubtedly the most portrayed architectural structure in the art of California and probably in the western United States. Artists were attracted to its unique beauty and romance, and paintings of the Capistrano mission achieved a great popularity in the first decades of the twentieth century.

One day last summer, Jerry Miller, the Administrator of the Mission San Juan Capistrano, called Jean Stern, Director of The Irvine Museum, asking to consult with him on conservation and restoration of several historic paintings in the mission's collection. I accompanied Jean on his visit to the mission. Jerry showed us the paintings, which proved to be important works by noted California artists. It was clear that these works needed conservation, and I offered to underwrite the costs of restoration. Afterwards, Jerry proceeded to give us a remarkable tour of the mission buildings and grounds. I then suggested that The Irvine Museum produce a book on the California missions as a subject in art, along with an exhibition that would reunite the Capistrano mission with the lovely art it inspired. A few days later, we met again and finalized plans for this project.

I hope that those who read this book will enjoy the history and romance of California's treasured missions and appreciate the truly timeless quality of these beautiful paintings that are so much a part of California's history.

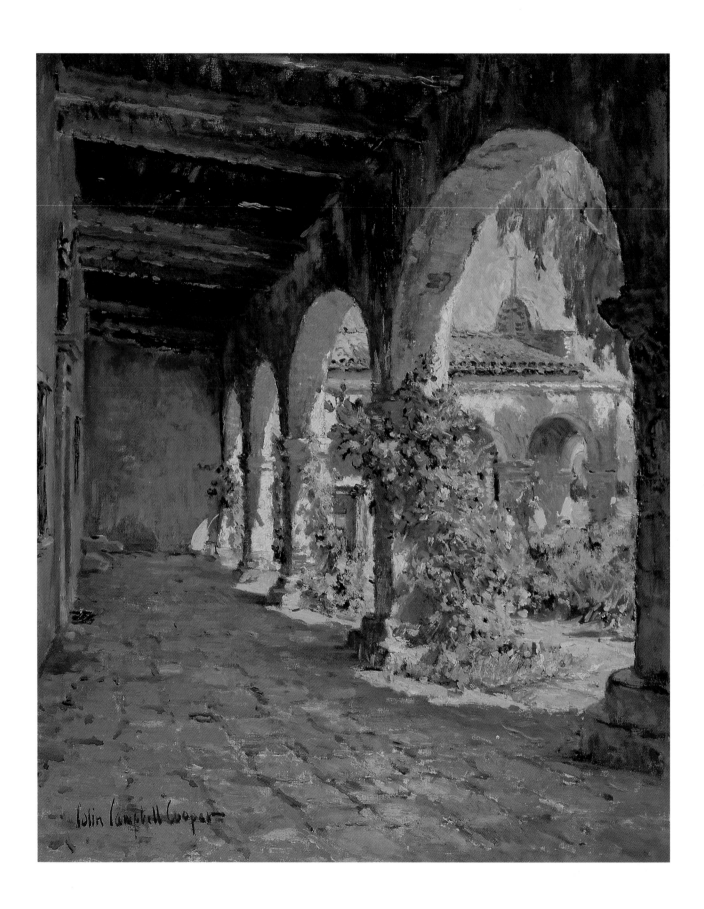

John Campbell Cooper

8

It All Started in St. Petersburg
by Gerald J. Miller

Sleds glided over crystalline snow, drawn by three-horse troikas with sleigh bells ringing, as nobility, members of the diplomatic corps, and court favorites dashed through the icy evening. Wind tugging at their hats, they skidded through the streets of St. Petersburg to the Winter Palace for the biggest event of the year 1768, the Royal Diplomatic Ball at the Court of Catherine the Great (1729-1796), Empress of all the Russias. It was more than a command performance; it was a chance to find out the latest news on Russian foreign policy. Catherine had just gobbled up a third of Poland, most of the Ukraine and all of the Crimea after defeating Turkey. European powers were all concerned that the Russians were coming. Party-goers were rewarded with Catherine's latest boast: Russia had expanded her North American colonies! The news sent shock waves throughout Europe. The balance of world power was threatened. Britain, France and Spain all had colonies there. How far had the Russians gone? Where were the Russians now? Britain sent her famous explorer, Captain Cook; the French sent the noted Bougainville; and Spain sent out parties by land and sea. Gaspar de Portolá was commissioned by King Carlos III of Spain to lead an expedition by land, to learn how far the Russians had advanced.

While Spain had claimed California since the 1500s, it had done little to settle and exploit its territory. The Portolá expedition of 1769 found that the Russians had reached as far south as Fort Ross, just north of San Francisco. Suddenly, Carlos III found it essential to undertake a major effort to develop California as a bulwark against Russian expansion. Without delay, the mission system was launched. Up and down the coast of California, padres and soldiers established the missions under Franciscan Friar Junípero Serra to colonize (Alta) California as a province of New Spain. Between 1769 and 1820, twenty-one missions were founded.

San Juan Capistrano, the seventh in the chain of missions, was founded in 1776. It was to become the most renowned and most romanticized of all the missions in story, art and song. It stands, more than two centuries later, in silent testimony to the imagination, courage, and artistic and architectural skill of its builders, both native and Spanish. The political reasons for it being built are long gone. Gone too are the urgencies generated at that cocktail party long ago. And gone are the empires represented there.

But the beauty and majesty of the historic missions are not gone. They have been immortalized by the scores of artists who captured in their sunlit and shadowed walls the spirit, the grandeur, the beauty and the romance of the old California missions.

Opposite:
Colin Campbell Cooper
Mission Corridor,
San Juan Capistrano
Oil on canvas
21 1/2 x 17 3/4 inches
The Fieldstone Company

It is to provide an opportunity to see collected in one place the best artistic representations of those monuments of ancient loveliness that Mission San Juan Capistrano and The Irvine Museum are collaborating on this memorable exposition. We are grateful to The Irvine Museum for selecting and gathering the many distinguished works and for the extraordinary efforts and guidance of its director, Jean Stern.

We are most appreciative and grateful to Joan Irvine Smith for her time, personal kindness and inspiration in conceiving this unique exhibition. The Mission San Juan Capistrano has long held a special place in Mrs. Smith's heart, and we are grateful too for her generosity in restoring many of the mission's historic California impressionist paintings. The long hidden beauty of these works can now be seen as part of this exhibition.

Right:
Arthur G. Rider
Mission Garden, 1930
Oil on canvas
18 x 22 inches
Laguna Art Museum, Gift of
Mr. Robert McChesney Bethea

Opposite:
Alson S. Clark
Ruins of San Juan Capistrano
Oil on board
31 x 25 inches

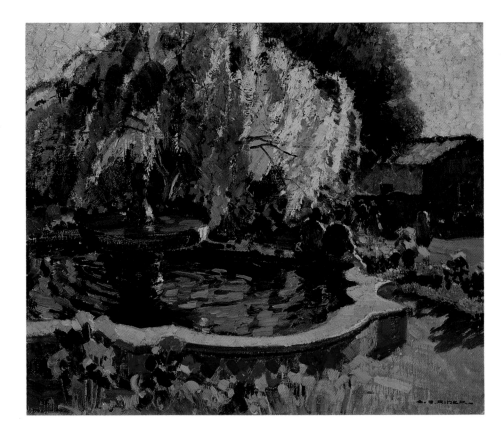

10

Acknowledgments *by Jean Stern*

On behalf of The Irvine Museum, I wish to thank Gerald Miller, Administrator of the Mission San Juan Capistrano, for his collaboration in the production of *Romance of the Bells*. From the start, Jerry has supported and guided the museum by offering both ideas and solutions to the myriad issues that inevitably appeared, often which seemed destined to delay the completion of our project. His knowledge of the history of the missions combined with his invariably good-natured outlook made our hurried and arduous task a pleasure.

Additionally, I am indebted to our authors, Pamela Hallan-Gibson and Norman Neuerburg, who have graciously offered their scholarship and insight on a subject in which they are the foremost authorities: the history of the California missions. They, too, pressed for time and working under looming deadlines, rose to the occasion and produced essays that reflect well on their expertise.

Many other people not credited on the title page were needed to complete this undertaking. I am grateful to all the assistance rendered to me by Holly Franks, Administrative Assistant to Jerry Miller at the Mission San Juan Capistrano. Moreover, I would thank the staff at The Irvine Museum, Merika Adams Gopaul, Janet Murphy and Brenda Negri, who did whatever needed to be done to make this project a reality. Additionally, I owe a debt to Pam Ludwig, Director of Joan Irvine Smith Fine Arts, Inc., for coordinating loans and obtaining photographs of paintings used in this project.

Many private collectors and public institutions contributed photographs of important and rare examples of paintings of the California missions. We are grateful for their generosity. Each is named adjacent to the illustration of the work of art.

In closing, I wish to recognize Joan Irvine Smith, President of the Board of Directors of The Irvine Museum. This project was born out of her great love for the Mission San Juan Capistrano and her desire to document the historical role of the California missions. Mrs. Smith and all of us who created this book wish also to share the beauty and importance of the paintings that make up this exhibition. Without her inspiration and her support, none of this would have happened.

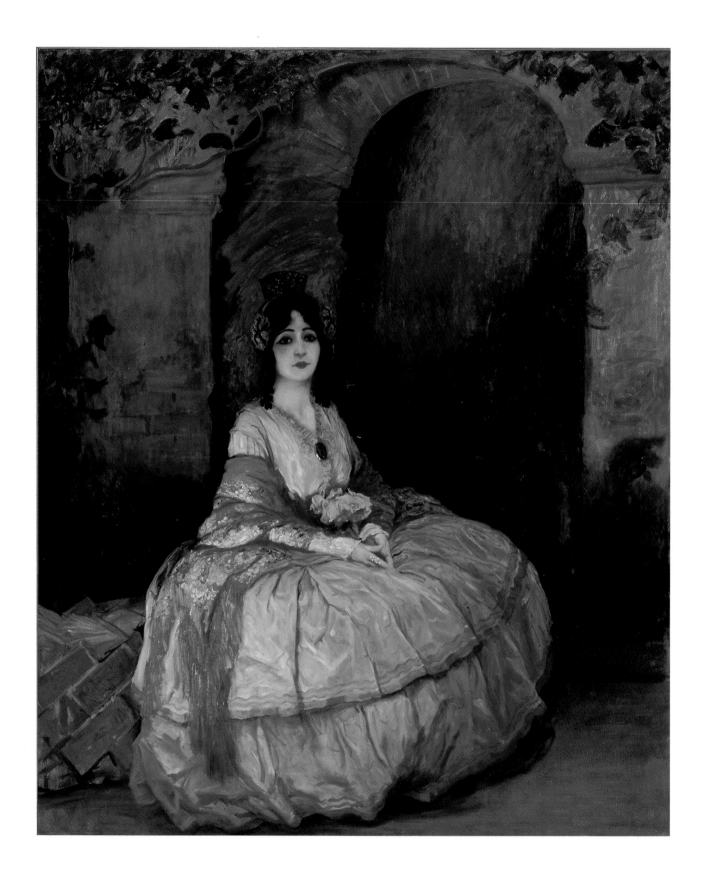

Spanish California *by Jean Stern*

Permanent European presence in what is now the United States began, of course, after 1492, the year that Christopher Columbus became the European discoverer of the New World. Thereafter, Spanish expeditions successfully established bases, at first on the islands in the Caribbean Sea, using them as stepping stones to the mainland. These military expeditions were driven by the hopes of finding new sources of wealth, but at the same time, the incursions were justified by a sacred duty: to systematically convert the native inhabitants to Christianity.

The first significant incursion into the North American mainland occurred in 1519 when Hernán Cortés set out to conquer the Aztec Empire in what is now Mexico. His small army was made up of about 600 soldiers, of whom 32 were crossbow men, as well as 14 cannons and 16 horses. The horse was perhaps Cortés' most valuable weapon, as it had never before been seen by the native peoples, and the sight of a charging horseman completely terrified large numbers of opposing troops. Cortés was consistently able to defeat a significant force of arms by taking advantage of his weapons of war and by arranging a series of alliances with other native states which were more than happy to see the Aztecs defeated.

A few years after the conquest of Mexico, Spain began to reach out toward the periphery of her new empire. In 1528 a small expedition led by Fanfilo de Narvaez landed on the coast of present-day Louisiana. As the men moved inland, they were continually opposed by armed Indians forcing them to retreat to the sea, near present-day Galveston. There the desperate men built crude rafts and sailed toward Mexico. They were shipwrecked and spent the next eight years making their way through northern Mexico, ending up in 1536 across the continent at the Pacific Coast near Culiacán in the state of Sinaloa.

The leader of the survivors, Nuñez Cabeza de Vaca, related a fantastic story he had heard of the existence of seven cities of gold called "Cíbola." He was taken to Mexico City where his report of these cities started numerous expeditions in search of them. In 1539, Marcos de Niza led an army in search of "El Dorado," the City of Gold. He was beaten back empty-handed, and in spite of having no tangible evidence, he reported that he had indeed seen cities of great wealth. In 1540, Francisco Vasquez de Coronado led an even greater force into the southwest, looking for Cíbola. After nearly two years of searching, he ended up in present-day Kansas before finally turning back to Mexico.

Further expeditions would be sent into the American Southwest for another forty years before the myth of El Dorado would be abandoned. Spain was finding greater wealth in the conquest of South America, and all further attempts to colonize North America were scaled down.

Opposite:
Guy Rose
The Leading Lady
Oil on canvas
72¹/₈ x 60³/₈
The Buck Collection,
Laguna Hills, California

Though not directly related to the El Dorado myth, California was not completely ignored as a possible source of gold. In 1542 the explorer Juan Rodriguez Cabrillo sailed north from Baja California to what is now Point Conception, just north of Santa Barbara. He encountered several Indian groups but found no evidence of great wealth. A few other expeditions followed, primarily with the intent of obtaining a more accurate map of the California coast, but no concerted efforts were made to settle or colonize the state for over two hundred years. It was not until 1769 that Spain established permanent colonies in California with the founding of the first mission in San Diego. The catalyst for this abrupt change, of course, was fear that the Russian Empire was expanding into California from colonies in Alaska and the Pacific Northwest.

With the mission system, Spain had a firm presence in California. The approximately fifty years that Spain colonized, occupied and ruled California ended in 1821 when Mexico gained its independence and in turn claimed California as its own. From 1821, in spite of restrictive travel and immigration measures by the Mexican government, the Americanization of California accelerated. In 1833 Mexico passed laws which secularized the missions, taking them away from the Catholic Church and causing their sale to private interests. California became an American possession after the defeat of Mexico in the Mexican War of 1846-48. The Gold Rush of 1849 followed, leading almost immediately to statehood in 1850. The romantic era of Spanish California was brief, yet the Spanish flavor remained into the Mexican era and was, in turn, institutionalized in the art and literature of the American period.

The twenty-one California missions and their assorted numbers of branch missions (*asistencias*) form the basis for the great romantic image of Spanish California that has come down to us in literature and art. The potent visual images of weathered adobe walls, red-tiled roofs, tranquil arcades, courtyards with fountains, gardens with pepper trees, bougainvillea and geraniums, pigeons cooing, swallows returning, mission bells ringing—all these romantic icons of California's past have their origins in the missions.

Opposite:
Manuel Valencia
The Cemetery,
Mission San Luis Rey
Oil on canvas
30 x 20 inches
De Ru's Fine Arts,
Bellflower, California

16

The Missions: A Story of
Romance *&* Exploration in California
by Gerald J. Miller

In 1769 Junípero Serra, a Franciscan missionary from Spain, arrived in San Diego to found the first mission. It was the beginning of a system of twenty-one missions that in only fifty-four years would reach 650 miles up the California coast. Spain had claimed Alta or Upper California for about 230 years before effecting any colonization there. Political expediency forced Spain's King Carlos III to take action. The Russians were becoming increasingly aggressive, extending farther and farther south from their territories in Alaska, eventually establishing Fort Ross, sixty-five miles north of present-day San Francisco. It is indirectly to the Russian explorations into California that we owe our mission establishments. The whole history of California would have been different if the missions had not been established. Spain in time lost out to Mexico, who lost to the United States in 1848. If Russia had reached beyond Ft. Ross and taken control of California instead of Spain, the United States would have had to confront Russia over California. Had Russia controlled California when gold was discovered, it is unlikely she would ever have relinquished the territory.

As a colonial enterprise, the missions were economical and inexpensive to maintain. A mission allowed the Spanish to control the land by occupying it. To discourage further southern encroachment by the Russians, the plan called for the padres to convert the natives to Christianity, to civilize them through education, and ultimately to make them loyal citizens of New Spain. Spain's investment was small: a mission required only the manpower of two padres and the protection of a few soldiers. After a few years of investment in supplies, the mission was to become self-sufficient. Mission lands were to be turned over to the natives as self-governing Spanish subjects after ten years' education and training in agriculture and industry. No property was owned by the padres.

Few mission lands were turned back to the native Indians because most lands were given or sold off to political friends of Mexico's governors after Mexico gained independence from Spain in 1821. Starting in 1833, by governmental decree, Spanish padres and mission Indians were driven out of the missions. The mission era was over.

The influence of the missions on California was great. California owes its existence as a state to Spain and the Franciscan missionaries. Because of that fact, the missions assume a new interest and a greater importance.

Some influences are obvious. Names and locations of major California cities, from San Diego to San Francisco, are all derived from mission sites. Pacific Coast Highway (Highway 101) follows the original *El Camino Real*, the "King's Road," that connected all the missions, spaced one day's journey apart.

Opposite:
Charles A. Rogers
Mission Garden, 1913
Oil on canvas
16 x 12 inches

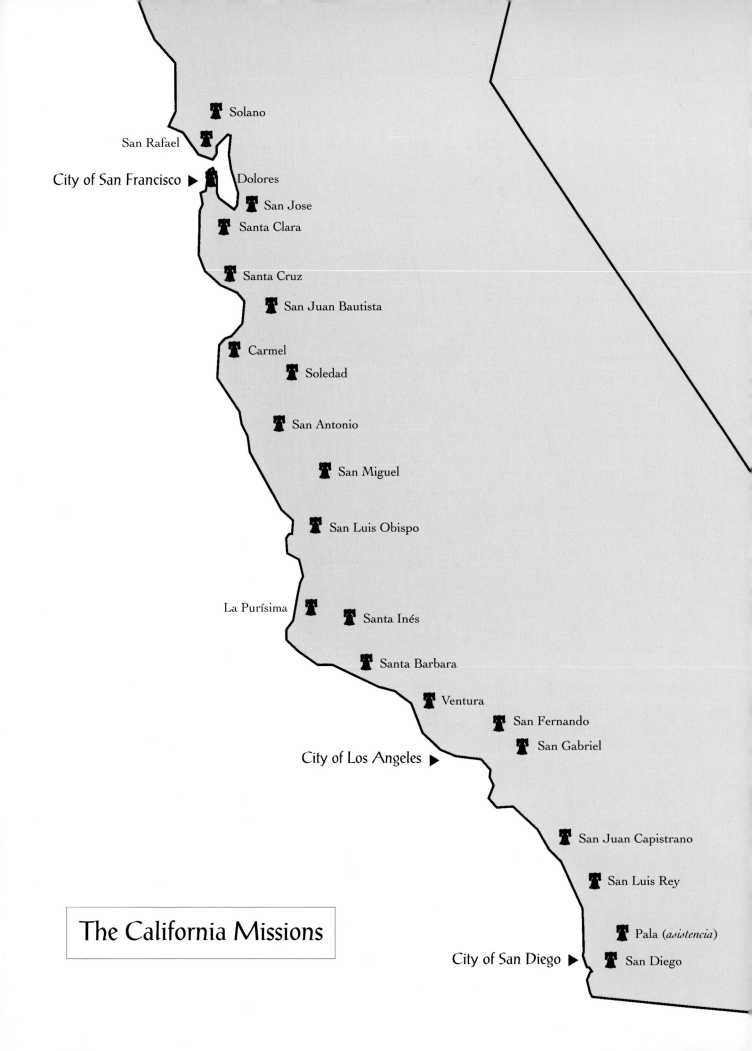

Solano

San Rafael

City of San Francisco ▶ Dolores

San Jose

Santa Clara

Santa Cruz

San Juan Bautista

Carmel

Soledad

San Antonio

San Miguel

San Luis Obispo

La Purísima

Santa Inés

Santa Barbara

Ventura

San Fernando

City of Los Angeles ▶ San Gabriel

San Juan Capistrano

San Luis Rey

Pala (*asistencia*)

City of San Diego ▶ San Diego

The California Missions

In today's California, mission style architecture is everywhere. Heavy walls, arcades, red roof tiles, large roof overhangs as protection from the sun and rain, all derive their influence from original mission structures.

Less obvious are the great agricultural economy of California which had its origins in the grains and vegetables first raised in mission fields and the great animal husbandry industry introduced with breeding herds developed at the missions.

The California mission era is a very romantic part of our history, and that beautiful heritage can be seen and relived at the restored missions along the California coast.

Mission San Diego de Álcala is the oldest mission in California, founded July 16, 1769, by Junípero Serra, the Father-President of the missions. Ironically, its beginning nearly caused the mission system to be aborted. Everything went wrong!

To establish Mission San Diego, two expeditions by land and two by sea were sent from Baja California. Two ships arrived in San Diego first. When the land expeditions arrived, they found the crews of both ships decimated by scurvy. Thirty-eight men had died. One of the ships, the *San Antonio*, had been sent back to San Blas, Baja California, for fresh supplies and new crews for both ships. One land expedition also went back to Baja California for more supplies.

Local Indians, the Yumas, more aggressive and warlike than Northern California tribes, attacked the Spanish, who appeared weak and defenseless. Spanish guns, however, drove off the attack. Six months later the mission founders were in critical condition. Nineteen more had died, and their supply ship was long overdue. Governor Gaspar de Portolá decided that unless the ship arrived by March 19, 1769, he would have to cancel the California expedition and order a return to Mexico.

Paul Grimm
San Diego Mission
Oil on canvas
28 x 36 inches
Joan Irvine Smith Fine Arts

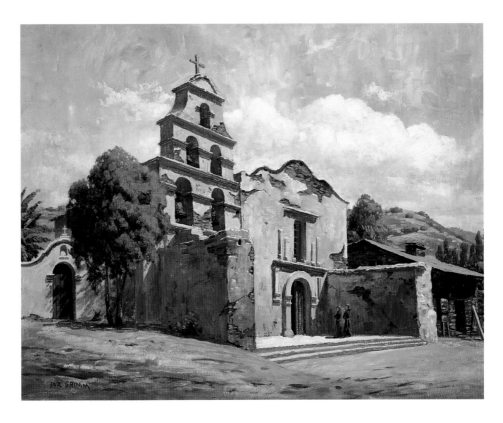

Father Serra prayed almost continuously for the return of the supply ship. On the evening of the 19th of March, just as the deadline was reached, sails were sighted, but inexplicably they disappeared below the horizon again.

Portolá decided to wait a little longer. Two days later the ship *San Antonio*, laden with supplies, dropped anchor in the harbor. The missions were a "go." Within a month Portolá led his overland expedition north, while Serra went by sea to Monterey to found a second mission.

The San Diego Mission was simpler in design than some of those that followed. Originally, the mission and the Spanish *presidio* (fort) were located on the hill above Old Town, San Diego, but the mission was moved shortly thereafter in 1774 to its present location five miles up the San Diego River. In 1775 the mission was all but destroyed in a violent Indian attack. It was rebuilt in 1780, but was badly damaged by an earthquake in 1801. It fell into complete ruin after the missions were disbanded by the Mexican secularization decree of 1833. When it was restored in 1931, the only remaining original part of the mission was the facade. The most notable feature is the *campanario* (bell wall) that has five bells hanging in niches. They were found scattered over a wide area. The largest bell weighs 1,200 pounds and was made from the five original bells given to the mission in 1796.

Mission San Carlos Borromeo del Rio Carmelo (Carmel) was founded June 3, 1770, by Father Junípero Serra as the second mission, beneath green mountains and beside the blue sea on the shores of Monterey Bay. It was moved to Carmel shortly after its founding because the soil in Monterey would not support farming and there was an insufficient water supply. Serra also desired to keep the mission Indians some distance away from the *presidio*. The Carmel Mission was Father Serra's headquarters for fifteen years. Father Serra died in 1784 and is buried there.

Seven different churches were built at Carmel. Serra ordered the quarrying of stone for a church in 1771, but its construction was delayed. The first mission church was crudely built of logs (1771). The ultimate church was started in 1791 by Father Lasuen, Serra's successor after his death. That church was built of stone by a master mason. It had two charming bell towers, uneven in size, one with a Moorish-style dome. The building had stone arches, a vaulted ceiling, and a unique star-shaped window over the front doorway. The mission church, a poet once wrote, seemed to "have been blown out of shape in some wintry wind, and all its lines hardened again in the sunshine of the long, long summer." It later fell into ruins, as did other missions, when it was sold off to private parties by the

Mexican governors. The church at Carmel today is one of the best examples of authentic restorations which has recaptured the stateliness of its early days.

The distance of 650 miles between missions at San Diego Bay and Monterey Bay was a serious predicament because supplies from Mexico had to be shipped over that great distance to sustain the new mission. To resolve the problem, it was decided to build missions in between as a supply line. Almost all the early missions were built along the coastline, in bays and harbors where ships with supplies could anchor safely. Each mission was about one day's travel from another along El Camino Real.

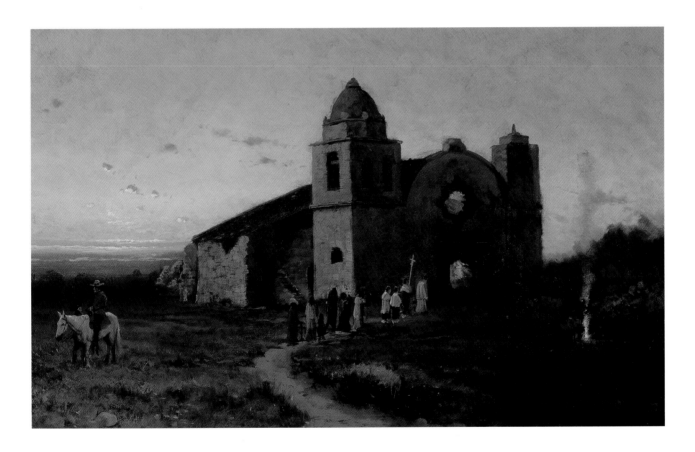

Jules Tavernier
Carmel Mission on San Carlos Day
Oil on canvas
18 x 29 inches
William A. Karges Fine Arts

Mission San Antonio de Padua, following San Diego and Carmel, was founded as the third mission by Father Serra on July 14, 1771, just after he had moved the second mission from Monterey to Carmel. Serra originally intended the third mission to be midway between San Diego and Monterey but was frustrated in such attempt by the governor. Instead he turned to an isolated, oak-lined grass-land location amidst rolling hills, a place recommended by Portolá after his visit there two years earlier.

Manuel Valencia
Mission San Antonio de Padua
Oil on canvas
30 x 20 inches
De Ru's Fine Arts,
Bellflower, California

Shortly after Serra's party arrived, an old Indian woman came to the encampment asking to be baptized. That astounded the padres because they hadn't been there long enough for her to know what a baptism was. She told a story of her father being visited on four occasions by a man wearing robes who told him about Christianity. The story related to a well-known southwest legend in which early missionaries in 1620 were surprised to find Indians who were well informed about the Catholic Church. The padres checked it and learned of a nun in Spain who said she and others had made many visits through supernatural teleportation to the Indians. Though she never left Spain, she backed up her bizarre story with accurate details about southwest locations and occurrences.

Serra left the mission in charge of Father Buenaventura Sitjar, who stayed for thirty-seven years.

The church of Mission San Antonio de Padua was known for its *campanario,* a bell wall in the front of the church with bells hanging over the entrance arches. After secularization in 1845, the mission was offered for sale, but there were no takers. Because the mission was so isolated, its disintegration was rapid, and it was plundered of all materials of value.

A successful restoration effort was started in 1948 with the help of the Hearst Foundation. Today, church and quadrangle have been restored and strengthened with steel and concrete.

Mission San Gabriel Arcángel, founded September 8, 1771, the fourth mission to be established, is older than nearby Los Angeles. It was from San Gabriel, ten years after its founding, that a small party consisting of two priests, Indian acolytes and eleven families traveled nine miles away to found *El Pueblo de Nuestra Señora, La Reina de Los Angeles*—the City of Our Lady, Queen of the Angels.

Mission San Gabriel is different architecturally from all other missions. Its fortress style is similar to the cathedral in Córdova, Spain, where the padre who designed it took his training. The Moorish influence can be seen in its capped buttresses and long, narrow windows.

The mission church, begun in 1775 and completed in 1805, has buttressed walls of stone and brick up to five feet thick. It differs in appearance today from the original. When the bell tower fell in the earthquake of 1812, the padres replaced it with its present *campanario* at the opposite end of the building.

San Gabriel also had a winery which was the oldest and, for many years, the largest in California. It was one of the busiest missions because it was located at the crossing of three main roads, two from Mexico and one from the east. Today it is a museum with one of the finest collections of mission era relics anywhere. For example, it has a hammered copper baptismal font given as a gift by King Carlos III of Spain in 1771, six priceless altar statues brought around the Horn from Spain in 1791, and a 300-year-old painting of the Virgin brought to the site by the founding fathers. It also has one of the saddest sights: a cemetery for 6,000 Indians, most of whom died from various epidemics.

San Gabriel was severely damaged by earthquakes in 1987 and 1994. Repairs are still being made.

Mission San Luis Obispo de Tolosa, fifth in the chain of missions, was founded by Father Serra on September 1, 1772. It is named for Saint Louis, Bishop of Toulouse, France.

This mission has its origins in a bear hunt! Portolá's expedition of 1769 was returning to San Diego after its unsuccessful search for Monterey Harbor. The men were half-starved. Entering a small valley, they found numerous bear tracks. The presence of game excited the starving Spaniards, who thought they could kill the bears easily with their muskets. When the first bear, a grizzly about eight feet tall and weighing 1,200 pounds, was wounded, it charged the startled hunting party, killing a horse and maiming some mules. It nearly got their riders before more shots brought it down. Portolá named the region the Valley of the Bears (La Cañada de los Osos).

Later, in 1772 when the missions at Carmel and San Antonio ran out of food, they remembered the bear feast. A new expedition was organized which shot,

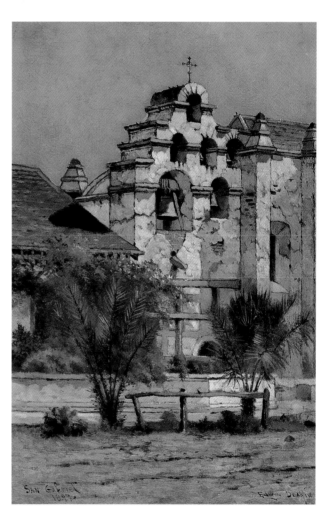

Edwin Deakin
San Gabriel Mission Bell Tower
Oil on canvas
18 x 12 inches
Dr. & Mrs. Edward H. Boseker

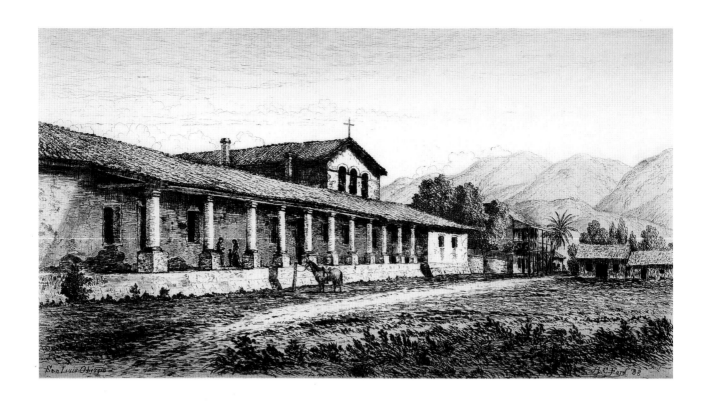

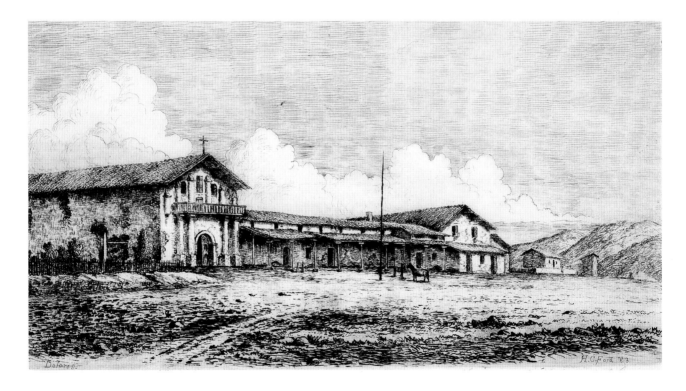

Henry Chapman Ford
Above: San Luis Obispo, '83
(Mission San Luis Obispo de
Tolosa), 1883
Below: Dolores, '83 (Mission San
Francisco de Asís, Mission
Dolores), 1883
Etching, *7 x 13 inches*

salted and jerked over 9,000 pounds of bear meat. They also obtained twenty-five bushels of edible seeds from trading bear meat with the Indians. Thus the California state animal, the grizzly bear, played a crucial role in the establishment of Mission San Luis Obispo.

San Luis Obispo was the first mission to use the red clay roof tiles associated with the missions. They were a response to necessity. The original roofs were made of tule reeds stretched across wooden beams. Not only were such roofs leaky, but the flaming arrows of unfriendly Indians could easily burn the mission down.

The padres, remembering the roof tiles familiar in Spain, determined to make clay tiles in San Luis. Using horses and mules to knead the native red clay in pits, they fashioned the clay over 22-inch wood molds (although legend has the Indian women fashioning these over their thighs) and fired them in a kiln. Once the tiles were in place, roof fires were no longer a problem, interiors were dry, and adobe walls were shielded from melting rains. Soon all the other missions adopted tile roofs.

The Mission San Luis Obispo was ruined by the Mexican land reforms, as indeed were all the missions. Between 1870 and 1880, the decaying church fell into the care of a group of self-appointed modernizers, which was perhaps worse than benign neglect. The "improvements" called for covering the facade with white clapboard and adding a New England style church steeple on the bell tower. Transforming the mission gave it a non-California appearance. In 1934 the wood siding was removed and the mission was restored to its original form.

Mission San Francisco de Asís (Mission Dolores), the sixth mission, was founded June 26, 1776, by Padre Francisco Palou. It was named for St. Francis of Assisi, founder of the Franciscan Order. The city that grew there took the name "San Francisco," in whose honor the mission was named, while the mission came to be called Dolores, after a little lake or inlet long since filled-in and covered with buildings. "Dolores" is Spanish for "pain," a fitting name in view of all the suffering that was endured there.

San Francisco Bay, with its coastal fogs and narrow entrance, was hidden to explorers of the 1700s until it was discovered by accident. When it was finally explored and charted, it was considered "large enough to hold all the armadas of Spain." The viceroy ordered two missions and a *presidio* built there.

In one of the biggest trail drives of all times, Juan Bautista de Anza led 240 settlers and about 1,000 livestock from Sonora, Mexico, over California's mountains, deserts and valleys to San Francisco to found a fort, a colony, and a mission

for Spain. They lost only one person, a woman in childbirth, and actually gained four healthy babies who were born en route.

De Anza selected the mission site with Father Palou. The early life of the mission saw suffering, attrition and disaster. Measles epidemics in 1804 and 1826 were main contributors to the 5,500 Indians buried there. Chilling fogs and persistent sea winds had a further adverse effect on the health of the Indians at Mission Dolores. That situation led the padres to look for a sunny location for a new mission to the north where sick Indians could recuperate (see Mission San Rafael).

The first mission church was a fifty-foot-long log and mud structure that was eventually moved because the lowland swamp on which it was built was unsuitable. The new structure was begun in 1782, completed in 1791, and has remained relatively unchanged since then. It has its original bells, hanging from rawhide thongs, which are still rung on holy days. Its exterior has Corinthian pillars and a simple balcony. The interior has Indian-designed chevrons painted on plain ceiling beams. The reredos (the decorative wall behind the main altar) and wall paintings are excellent examples of early California art.

Of the original mission, only the church remains. It is the oldest building in San Francisco, having come through the great earthquake and fire of 1906 unscathed.

Mission San Juan Capistrano was founded November 1, 1776, by Padre Junípero Serra. Originally, it was established October 30, 1775, at which time a temporary chapel was built, bells were hung, and religious services were held. After about two weeks, news came from San Diego of Indian attacks. The missionaries quickly packed up their things, buried the bells under some oak trees a short distance east of the present mission, and returned to San Diego. It lay abandoned until its refounding the following year.

Mission San Juan Capistrano is at once the most tragic, the most romantic, the most renowned of all the old Spanish missions, and probably the most beautiful. Truly it justifies its title, "Jewel of the Missions." (For a complete discussion of the history and romance of Mission San Juan Capistrano, please read the article by Pamela Hallan-Gibson in this book.)

After outgrowing "Father Serra's chapel," the little adobe church so called because it is the only building still standing in which Junípero Serra is known to have conducted services, the padres at San Juan built a great stone church whose sophistication surpassed all other buildings in California. With the help of a gifted stone mason from Mexico, they built a magnificent 180 foot by 40 foot cruciform structure with vaulted ceilings and seven domes all of stone quarried six miles away.

One cold December morning in 1812, six years after the church had been completed, as Indian converts celebrated Mass, a severe earthquake shook the tower and church. Walls swayed and collapsed on the congregation, killing forty people. Adequate resources would never again be gathered to rebuild the church. What had been the most imposing edifice of its time had become California's most beautiful ruins. Religious services were once again held in the little adobe church known as Serra's Chapel.

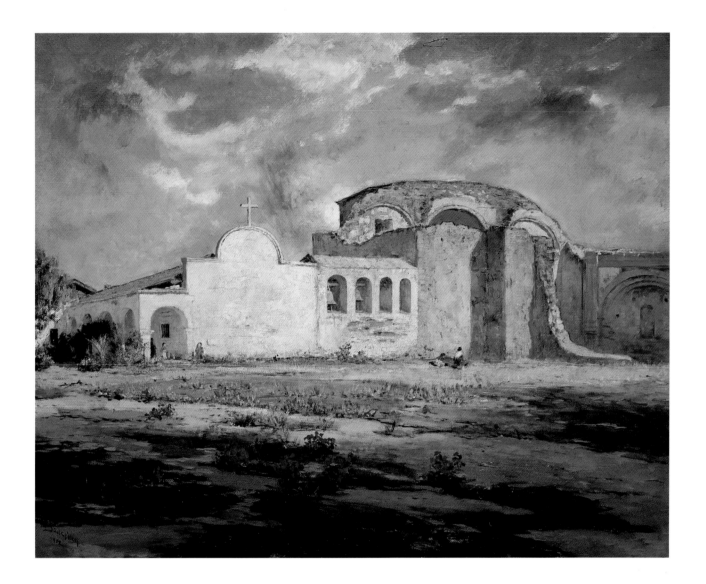

Life at San Juan Capistrano went on. An early report by Richard Henry Dana in *Two Years Before the Mast* tells of dried cattle hides, prepared at the mission, being thrown from cliffs at Dana Point to be regathered and packed off on ships below to New England shoe manufacturers.

The mission was sacked by pirates in 1818 when the Argentine privateer Hippolyte Bouchard put into Dana Point Harbor and was refused supplies.

There are the fabled arches, the graceful ruins, the Moorish fountains, and today the beautiful gardens reminiscent of the Alhambra in Spain. And there are the swallows, those romantic symbols of nature's migrations with the seasons. The romantic legend of the swallows and their annual return to Capistrano every spring on St. Joseph's Day has captured the imaginations of millions and provided a major media event every year. Mission San Juan Capistrano is continuing its restoration efforts as funds permit.

Frank P. Sauerwein
Mission San Juan Capistrano,
1902
Oil on board
24 x 30 inches

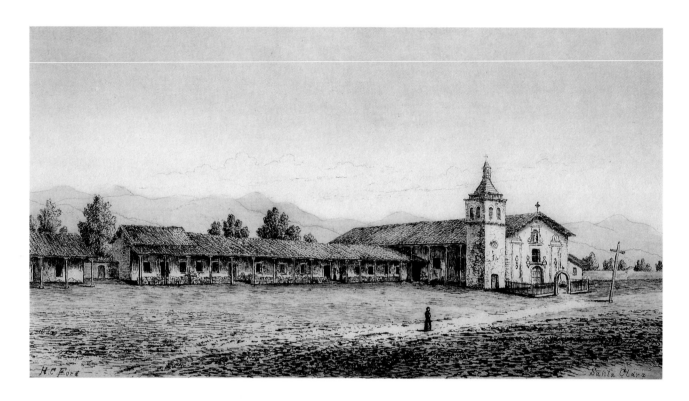

Henry Chapman Ford
Santa Clara (Mission Santa
Clara de Asís), c. 1883
Etching
7 x 13 inches

Mission Santa Clara de Asís, the eighth mission founded by Padre Junípero Serra on January 12, 1777, was named for Clare of Assisi, founder of the nuns called "Poor Clares." A day's journey south from San Francisco's Mission Dolores, it was once the most prosperous of missions, endowing the Santa Clara Valley with its famed agricultural reputation. It was secularized by the Mexican governor in 1836 and fell into ruin. It was operated as a parish church under a Jesuit pastor, who turned it into a college in 1851. It has been used as an educational institution ever since. It is one of California's oldest schools of higher learning.

The original mission buildings were destroyed over the years by flood, earthquake and fire. Today's university chapel is a reproduction of the old mission church. The bell tower contains the last of the original bells which came from Spain 200 years ago.

Mission San Buenaventura was the ninth and last mission founded by Juníper Serra, in 1782. It is the midway point in the north-to-south mission chain. Once surrounded by orchards, vineyards and grain fields, it was the garden spot of the missions, nestled between the foothills and the ocean. It was situated beside a village of 500 Chumash Indians. Today, that locale has become the heart of the business community in the city of Ventura.

The original church burned down before getting a tile roof, and the second one fell in the earthquake of 1812. The church today is a replica of the original, with an unusual triangular design said to represent the Holy Trinity. The two large Norfolk Island pines in the garden are a hundred years old, reputedly planted by a sea captain who hoped to grow a forest for use as ships' masts.

In the museum are two old wooden bells, survivors of the church's disasters, the only ones of their type in California.

Henry Chapman Ford
San Buenaventura '83 (Mission San Buenaventura), 1883
Etching
7 x 13 inches

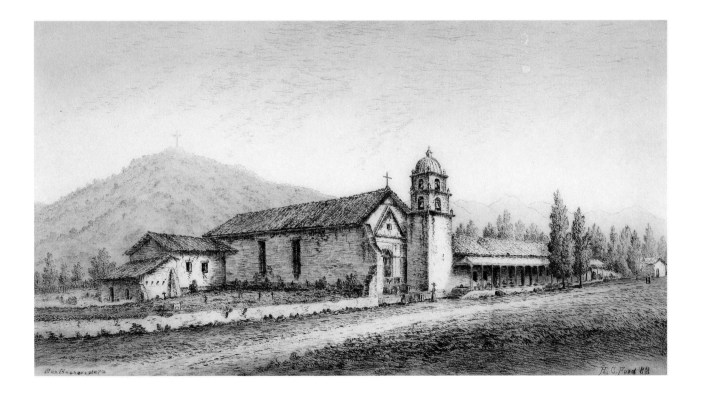

Mission Santa Barbara, founded in 1786 as the tenth mission, was dreamed of by Father Serra, founded by Father Lasuen, but was designed as a Greco-Roman temple by a man who had been dead for 1,800 years before the mission was built!

In 27 B.C., a work, *Six Books of Architecture,* was published which became a standard for centuries. When Santa Barbara Church was planned, Padre Antonio Ripoll lifted every detail of the Greco-Roman facade from the *Six Books.*

The church has been rebuilt several times to counter damage from earthquakes and secularization, although it was never abandoned. Restored, it stands today, known as the "Queen of the Missions," majestic and serene, in a natural amphitheater formed by coastline and the Santa Ynez Mountains. The interior has changed little since 1820. The old reredos, along with paintings and statues that were brought from Mexico in 1800, are still there. It is the only mission church with two matching towers.

The nearby coast was thickly settled with 10,000 Indians living between San Buenaventura and Point Conception. Santa Barbara Indians belonged to the Chumash tribe, who were fishermen, skillful in coastal waters with their long canoes. They were friendly and hospitable to the missionaries.

Santa Barbara is the only mission in California that remained under control of the Franciscan Order continuously from its founding to the present day. All others were abandoned after Mexican secularization robbed the missions of their lands and scattered their congregations of native converts.

Theodore Wores
Mission Santa Barbara
Oil on board
10 x 12 inches

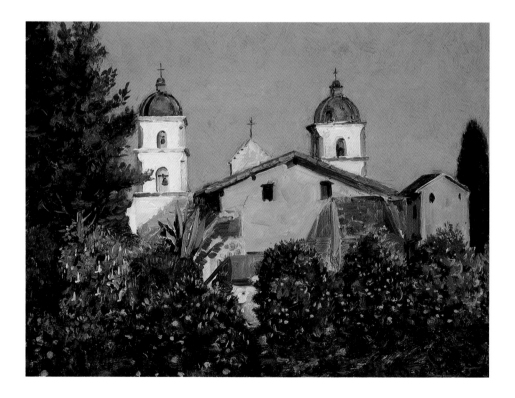

Santa Barbara was noted for its water system, the most elaborate in all the missions, parts of which are still in use today. It was always a prosperous and attractive mission, situated near a busy port. The grounds never suffered the destruction that occurred at other missions after secularization because it changed quietly from a mission for Indians to a parish church for white settlers.

Mission La Purísima Concepción was founded December 4, 1787, as the eleventh mission, midway between Santa Barbara and San Luis Obispo. One of the largest missions, it had over 1,500 Indian converts and over 20,000 head of livestock. It became an important supply base because after 1812 no supplies were brought by ship for the *presidios*. They had to depend entirely on the missions for food, clothing, leather goods and blankets.

Earthquakes struck the mission in 1812, causing in turn the collapse of a natural dam in the hills above the mission, which allowed water to flood over the grounds. A new site was chosen four miles away and prosperity returned only to be followed by a new chain of disasters. Fires destroyed some buildings in 1818. Indians rebelled against the soldiers in 1824, turning La Purísima into an Indian fort for over a month. Their stronghold, the mission, was reduced by cannon fire from the *presidio* soldiers from Monterey. In the end, the mission was completely destroyed. Any Indians lingering about the ruins were decimated by smallpox in 1844.

A. Marshall
Mission La Purísima, 1903
Oil on canvas
12 x 28 inches

Rebuilding was started by the Civilian Conservation Corps in 1935. Restoration culminated in 1951. The most completely restored mission in the West, La Purísima is today a 967-acre historic park owned and operated by the State of California.

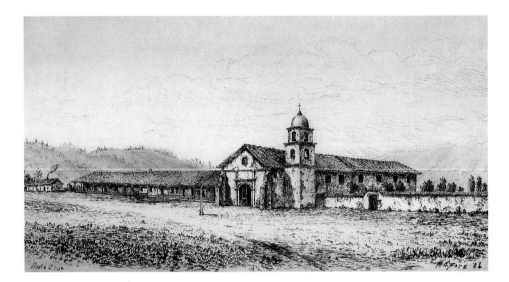

Henry Chapman Ford
Santa Cruz, '83 (Mission Santa Cruz), 1883
Etching
7 x 13 inches

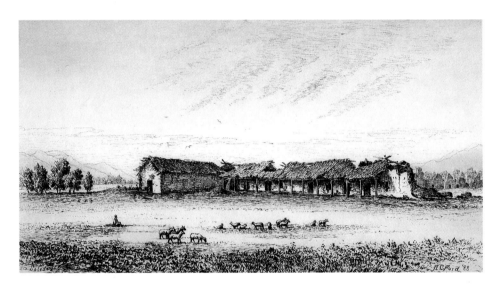

Henry Chapman Ford
Soledad, '83 (Mission Nuestra Señora de Soledad), 1883
Etching
7 x 13 inches

Mission Santa Cruz, the twelfth mission, founded in 1791 by Father Lasuen, seemed to have the perfect site, and although it was the smallest mission, it prospered for a few years. Soon, however, trouble arrived from the *pueblo* (town) which was established across the river. The settlers were an assortment of criminals, indigents and sick people who caused continuous friction with the padres and mission Indians. When Mission Santa Cruz was secularized by the Mexican governor, its cattle were sold, Indians driven away, and lands granted to private individuals. Later, an earthquake and tidal wave destroyed most of the buildings. The remaining walls crumbled in 1851. Timbers, tiles and foundation stones were carried away by scavengers.

Today, only a half-size replica of the church and a portion of the cloister wing have been built on the approximate site of the old mission.

Mission Nuestra Señora de Soledad, the thirteenth mission, was founded in 1791 by Father Lasuen and named after Our Lady of Solitude. It was an appropriate name. Considering the number of padres who served there, thirty priests in forty-four years, it must have been regarded as the "Siberia" of the missions. The site is alternately damp or bone dry and unceasingly windy. Even today it's regarded as a lonesome, forlorn place. Yet it was always good sheep country, and Soledad had 6,200 sheep by 1832, when a sheep was twice the price of a horse.

Disasters were continuous. In 1824 the Salinas River flooded the church. In 1828 floods washed away the chapel that had been built to replace the first, and a smallpox epidemic killed hundreds of Indians. The last priest, Father Sarria, died at the altar. Then the mission died. The Indians left and the Mexican government took away the roof to pay a debt!

Today a small chapel and one wing of the quadrangle stand restored amidst blowing winds and melted mounds of adobe.

Mission San José de Guadalupe, 1797, was established north of Santa Clara as a half-way point between the pueblos of San Jose and San Francisco, at the apex of the San Joaquin Valley. More Indian conversions (6,700 converts in thirty-one years) occurred at that fourteenth mission than at any other northern mission, primarily because of its leader, Padre Duran. Musically self-taught, he formed a thirty-piece band with handmade instruments and taught the Indians Gregorian chants, masses, hymns and songs.

The mission buildings were not extensive. Except for a small section of adobe wall, it all disappeared because of earthquakes and neglect. A white New England style frame church was erected on the site in 1868. From 1982 to 1985, an adobe mission church was rebuilt on the original foundation, and the white frame church and rectory were moved.

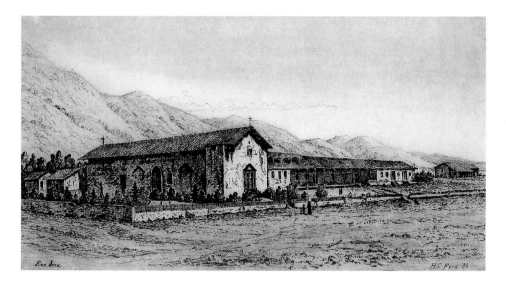

Henry Chapman Ford
San José, '83 (Mission San José de Guadalupe), 1883
Etching
7 x 13 inches

Mission San Juan Bautista, named for John the Baptist, was built in 1797 as the fifteenth mission, unwittingly right on top of the "mother" of all seismic features, the San Andreas Fault. A temblor in 1800 warned its builders that plans for a massive three-aisled church were perilous. In response, they walled the supporting arches that separate outer aisles from the nave. When the great earthquake of 1906 left most of Northern California in piles of debris, the church's center section survived while outer walls on both sides collapsed. These were finally repaired in 1976. With its three naves, it is the widest mission church in California.

The mission was noted for its cooperative local Indians and for its ravenous fleas, which attacked everyone without respect to race.

Music played an important part in the life of the mission. Indians were taught to read notes in a system devised by Padre Tapis. Later a barrel organ was played for attacking Indians from a neighboring tribe. They were soothed and persuaded to join the mission so they could hear the organ regularly. The barrel organ may be seen at the mission today.

The church and other original mission structures were used after secularization for hotels, stables and individual dwellings. In 1859 the mission was returned to the Church, minus a few buildings. In 1949 it was restored with financial assistance from the Hearst Foundation.

Henry Chapman Ford
San Juan Bautista, '83 (Mission San Juan Bautista), 1883
Etching
7 x 13 inches

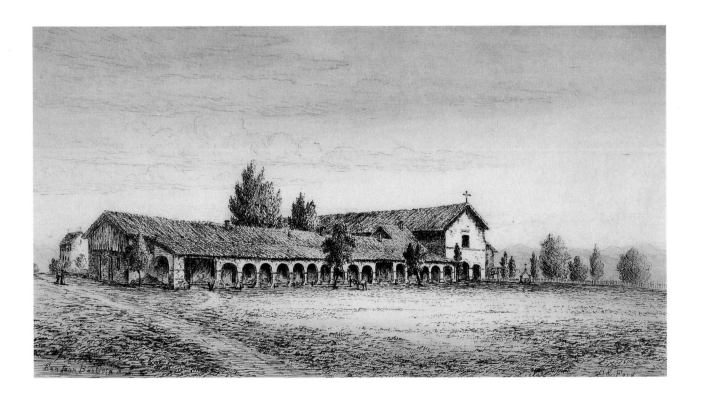

Mission San Miguel Arcángel, the sixteenth mission, was founded in July 25, 1797, to fill the gap between San Antonio and San Luis Obispo. Two other missions were built that summer to close gaps between missions along El Camino Real. San Miguel attracted converts from the San Joaquin Valley, mostly Tulare Indians named for the tule swamps beyond the mountains.

San Miguel prospered thanks to its good soil and adequate water. It gained 1,000 converts by the fourth year of operation. It had high productivity in crops and livestock, with huge ranches extending fifty miles north and south.

The first church had no roof tiles and burned in 1806. Large stores of hides, grain and wool were lost. A new church, completed in 1816, is noteworthy today for its unretouched interior paintings, the best surviving examples of mission art. Most impressive is a mural over the statue of St. Michael of the all-seeing eye of God that appears hypnotic to the beholder. Paintings in the church were mixed with animal glue or were painted on damp plaster. Colors were obtained from nature: red from rocks, blues from wildflowers, greens and pinks from other plants.

After secularization, the mission was abandoned for thirty-six years. All of the buildings were sold. Some buildings were restored in 1928, and the main buildings were turned over to the Franciscans to operate as a parish church and monastery. It is a distinctive mission for it has no bell tower. It does have the original free-standing *campanario,* which is still in use.

Henry Chapman Ford
San Miguel, '83 (Mission San Miguel Arcángel), 1883
Etching
7 x 13 inches

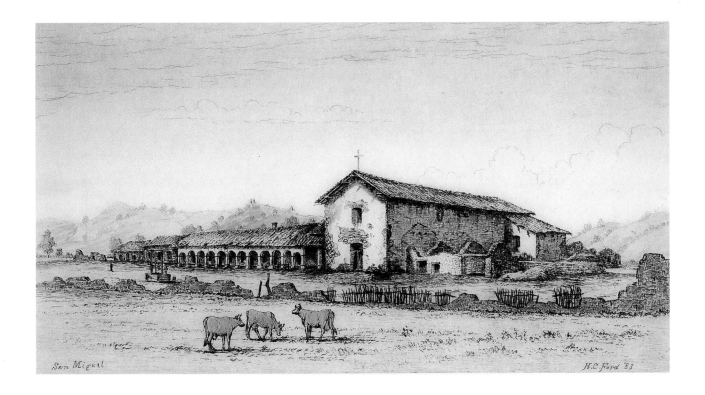

San Miguel H.C Ford '83

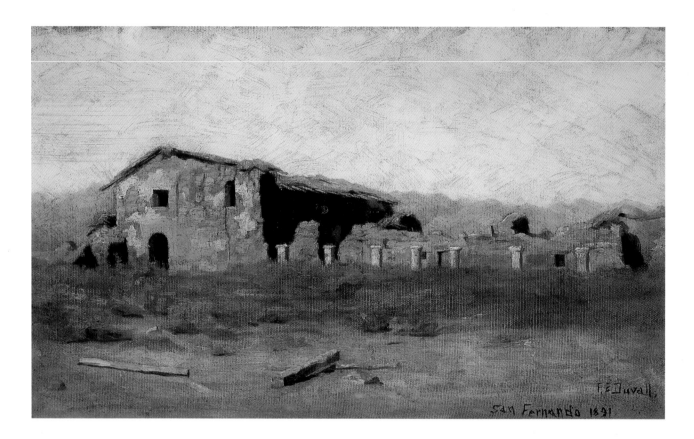

Fannie E. Duvall
San Fernando, 1891
Oil on canvas
13³/₄ x 22¹/₂ inches

Mission San Fernando Rey de España, was the seventeenth mission. Father Serra and his successor, Father-President of the Missions Fermin Lasuen, had planned for an inland chain of missions to connect San Gabriel with missions to the north. Of the four inland missions, San Fernando is the southernmost link. It is named after King Ferdinand III of Castile, canonized for his thirteenth-century wars against the Moors in Spain.

Mission San Fernando is located between San Gabriel and Buenaventura Missions. It acquired 1,000 residents in two years and had over 21,000 head of livestock grazing throughout the fertile San Fernando Valley.

San Fernando experienced a gold rush in 1842, preceding the great 1849 rush at Sutter's Mill. A ranch foreman was pulling onions when he discovered gold flakes in the dirt. An army of diggers followed, but the small bonanza was depleted in a few months.

Secularization resulted in decay and abandonment. Robbed of their protective tiles, the adobe walls melted from exposure. Other buildings were used as warehouses and stables, and the patio was used as a hog farm. In 1916 local citizens held candlelight processions and raised money to start restoration. In 1923 church officials returned to take up restoration work. The beautiful "long building," a 243-foot long, two-story hospice (hotel), the largest adobe building in California, is intact and is used as a museum. It also houses a wine press, a smoke room, a refectory and the Governor's Chamber, which was used by important visitors in bygone days.

The Sylmar earthquake of 1971 severely damaged the chapel. In 1974 an exact replica was completed. Unfortunately, it sustained some damage in the Northridge earthquake of 1994.

Mission San Luis Rey de Francia, the eighteenth mission, was founded on July 13, 1798, by Padre Lasuen and named after Louis IX, King of France canonized in 1290 for crusades in Egypt and the Holy Land. It is the link in the gap between San Juan Capistrano and San Diego missions.

San Luis Rey is called the "King of Missions" because by 1832 it had more livestock than any other mission: 57,300 head. Just before secularization it was also the most populous mission with 2,788 Christianized Indians.

The mission has a cruciform church—a blend of Spanish, Moorish and Mexican influences—with a single bell tower. This sophisticated building seats 1,000 people. An unusual feature of the church is a

Chris Jorgensen
Mission San Luis Rey, 1903
Watercolor
14 x 9 inches
The North Point Gallery,
San Francisco

mortuary chapel and balcony above the nave so relatives could watch over their deceased.

The mission has sunken gardens and a well-planned laundry complex. It obtained water from a spring system with a charcoal filter through which irrigation water flowed to the fields and six acres of buildings around a 500 by 500 foot quadrangle. The first pepper tree in California was planted at San Luis Rey in 1830.

After secularization, San Luis Rey was abandoned by 1846 and the property sold to relatives of the governor. In 1865, President Lincoln returned the mission to the Church, but restoration work was not begun until 1892. Restoration of the mission is still ongoing. It is operated by the Franciscan Order, who carry out restoration work as funds permit.

Mission Santa Inés, located in rolling hills in perhaps the most idyllic setting of all the missions, is called the "Hidden Gem of the Missions." Started on September 17, 1804, by Padre Esteban Tapis and named after St. Agnes, it was the nineteenth mission dedicated and the last to be built between San Diego and San Francisco.

Henry Chapman Ford
Santa Inez, '85 (Mission Santa Inés), 1883
Etching
7 x 13 inches

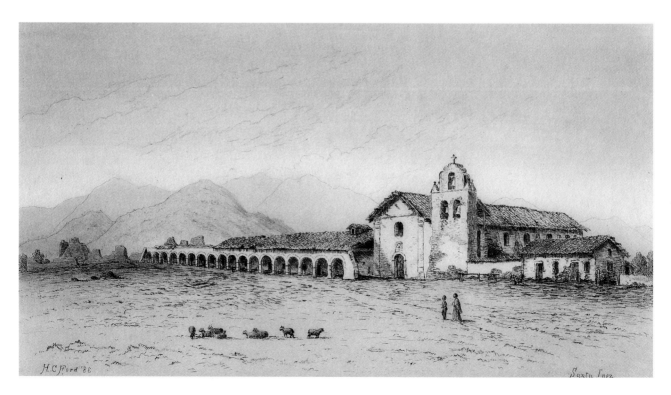

Severely damaged by the earthquake of 1812, a new church was finished in 1817, with a distinctive *campanario* of three bells. Designs on the rear wall of the altar were painted by Indians using native vegetable colors. A very old polychrome wood carving of St. Agnes is over the main altar.

Indians at Santa Inés revolted in 1824 because of burdens imposed by the Mexican government after its revolt from Spain in 1821. Tensions underlying the rebellion caused troubles throughout the mission chain. The padres could not control the soldiers when incidents with the Indians occurred. That situation was exacerbated when Mexican laws called for the expulsion of all European-born people in California.

After the Indian rebellion, the mission declined prior to secularization in 1836. It served briefly (1844-1846) as headquarters for educational institutions until it was sold in 1846. In 1862 it was returned to the Church. Today the restored church, sacristy and several buildings form an L-shaped group which only suggests the size of the original mission.

Mission San Rafael Arcángel, the twentieth mission, founded in 1817, was the only mission established as a hospital. So acute was the problem of illness among Mission Dolores Indians that both padres and civil authorities sought the sunny, warm, dry hillsides north of San Francisco (Marin Peninsula) as a place for sick Indians. It was established as a branch mission (*asistencia*), named after the Archangel Raphael whose name means "healing power of God."

Mission San Rafael offered an additional, and not quite so altruistic, incentive for civil authorities to approve its construction. There were fears that the Russians might expand from their outpost at Fort Ross into Spanish territory near San Francisco. Spain wanted a firmer claim on the land, and missions north of San Francisco were the most efficient means.

San Rafael had only a small church with star windows and a bell hung on cross beams. It had just one wing besides the infirmary. With medical help and a better climate, the Indians were able to recover. Other missions began sending their sick to convalesce in the sun. In 1823 San Rafael was elevated from *asistencia* to mission status and eventually became self-supporting. The mission introduced pears for which the region is still known.

San Rafael Arcángel was the first mission secularized (1833), sending it into decay. It was sold in 1841, but was abandoned a year later. It was returned to the Church in 1855.

Today, there are no tangible remains of the original Mission San Rafael Arcángel. A restoration of the mission was constructed on the approximate site, showing some of the characteristics of the original mission church.

Mission San Francisco Solano, the twenty-first and last mission, was built in 1823. Once again, hysteria over potential Russian expansion had given Governor Don Luis Arguello sufficient reason to approve a new mission farther north. Mission Solano was founded on July 4, 1823, by Padre José Altimira without knowledge or approval of Father President Senan, who lay dying. Senan rebuked both the panicky governor and Altimira.

Ironically, the Russians surprised everyone by donating a bell, utensils and other useful things to get the new mission started. In the end, the Russian threat never materialized.

The mission grew rapidly and soon had a wooden church, granary, work-shops, monastery, vineyards and fields of crops. Father Altimira showed little tact with the Indians, and they promptly rebelled, forcing him to flee. Efforts to revitalize the mission failed, and in 1833 it was secularized by the Mexican governor, whose administrator, Vallejo, removed to his ranches all Indians, cattle and fruit trees from the mission. It has been said that Mission Solano started and ended its brief nine year life as a pawn in early California power politics.

In 1846, near Mission Solano, a group of Americans who captured Vallejo raised a crude flag with a picture of a bear on it, initiating the famous Bear Flag Revolt that inaugurated the California Republic. The landing of United States Marines at Monterey put an end to the brief episode of California as an independent country.

During the early 1900s, work was begun to restore the mission to its present state. It is now known as Sonoma Mission State Park.

Thus ends the brief, glorious saga of the California missions, the chain of twenty-one missions established in the wilderness around which the modern coastal cities of California developed.

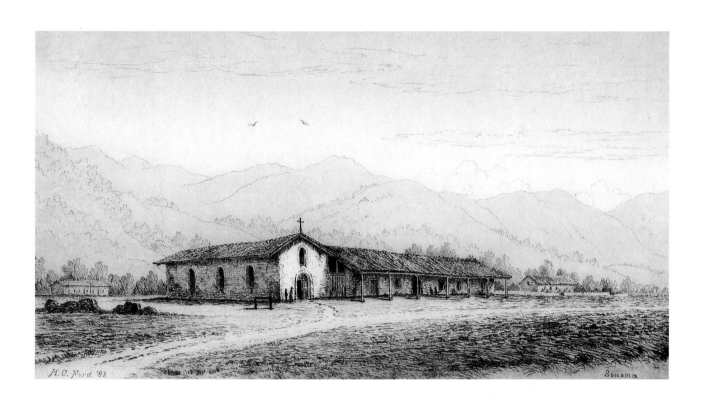

Henry Chapman Ford
Sonoma, '83 (Mission
San Francisco Solano,
Sonoma Mission), 1883
Etching
7 x 13 inches

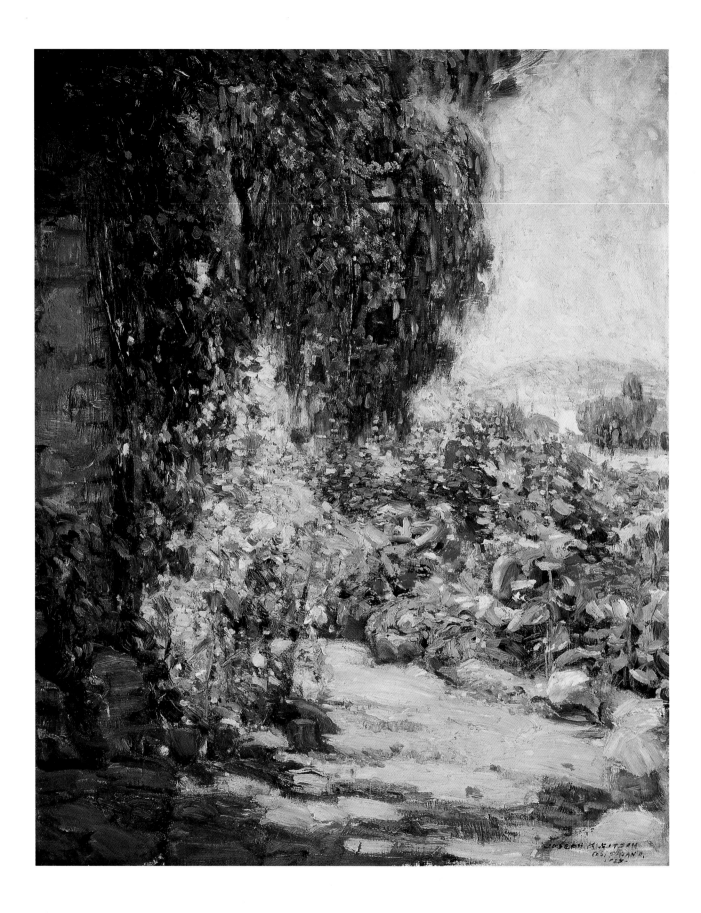

Mission San Juan Capistrano
by Pamela Hallan-Gibson

Mission San Juan Capistrano has been called the "Jewel of the Missions." It is a place where light and shadow create dimensions of time and space, where ruby blossoms and bougainvillea spill over stone walls, where multicolored beds of roses create clusters of scent and color against a background of brown soil and adobe walls. Visitors are both soothed and stimulated as they stroll down ancient walkways where the sandals of gray-robed friars once walked.

The brilliance of color and light have inspired artists through the centuries to transfer the jewel-like qualities of the mission onto paper and canvas. But Mission San Juan Capistrano has had other sources of inspiration. Its quiet presence in the heart of the city that bears its name has given people a sense of place. It has stood for over 200 years as a symbol of faith and endurance, and has not only survived, but has also given shape and definition to the community that has grown up around it.

Today it is a walled oasis, where one can shut out the tension and turbulence of the outside world and become lost in the quiet ambiance of the past. But Mission San Juan Capistrano has not always been a place of peace. Its beginnings were rough and uncertain, its founding overshadowed by events that threatened its existence. Yet those charged with the establishment of the mission system in Alta California in the eighteenth century moved purposely forward, inspired by the belief that if they hesitated a generation of souls would be lost to heaven.

The missions of Alta California were part of a settlement plan for claimed territories which had evolved through 250 years of Spanish history. It called for the creation of military outposts to secure the territory, followed by missions used to instruct the native populations. Then came settlers who founded towns, bringing with them their culture. It had worked in South America and Mexico—they hoped it would work here.

The responsibility for scouting locations for future mission sites rested with Father Juan Crespi, who accompanied the expedition led by Gaspar de Portolá which set out from San Diego in the summer of 1769. Their goal was to explore territory between San Diego and Monterey. In July the sixty-two-man force crossed San Juan Creek, then unnamed, and camped near its banks. Father Crespi described the future site for a mission: "A little before eleven we came to a very pleasant green valley, full of willows, alders and live oaks and other trees not known to us. It has a large arroyo, which at the point where we crossed it, carried a good stream of fresh and good water, which after running a little way, formed into pools in some large patches of tules. We halted there, calling it the valley of Santa Maria Magdalena."

Opposite:
Joseph Kleitsch
Bougainvillea, Mission San Juan Capistrano
Oil on canvas
30 x 24 inches

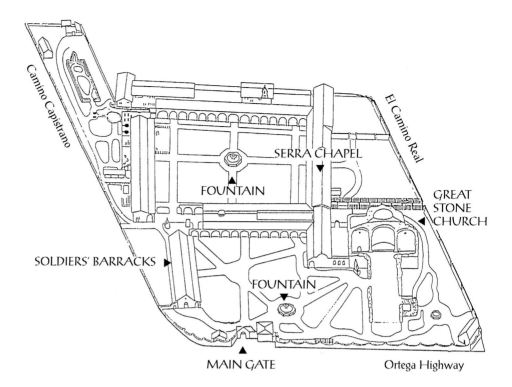

SERRA CHAPEL

FOUNTAIN

GREAT
STONE
CHURCH

Camino Capistrano

El Camino Real

SOLDIERS' BARRACKS

FOUNTAIN

MAIN GATE

Ortega Highway

Plan courtesy of D. Schiffert

The expedition marched on and eventually, having miscalculated the distance, ended not at Monterey Bay, but at San Francisco Bay. The friars nonetheless remembered the mission sites they described along the way. In 1775, when Father Junípero Serra was given permission to establish the seventh mission, he returned to the "pleasant green valley" and founded Mission San Juan Capistrano, named for St. John of Capestran, Italy, a Franciscan whom Father Serra admired.

Building a mission was not easy. Supplies were limited and the reception by the Indians was unpredictable. Fathers Fermin Francisco de Lasuen and Gregorio Amurrio had barely started when they received word of an Indian uprising in San Diego. The soldiers with the founding party were needed. The bells were quickly buried, and the group returned to San Diego.

A year later, November 1, 1776, Father Amurrio returned. The bells were unearthed, and Father Junípero Serra officially founded Mission San Juan Capistrano in the presence of Amurrio, Father Pablo Mugartegui, and many curious onlookers from neighboring Indian villages. They called the Indians *Juañenos*, after "Juan" in San Juan Capistrano.

The founding document of the mission indicates new missions were totally dependent on other missions, which generally had little to spare. San Gabriel mission contributed nine milk cows, a breed bull, a yoke of oxen, mules, horses, pigs, chickens and various tools. Construction was inconvenient and difficult— adobe bricks were formed and set in the sun to dry; wooden beams were hand cut from felled trees and transported to the building site; laborers were recruited from the native population, who fortunately were willing to help, since soldiers assigned to the garrison were not.

In October of 1778, the mission moved from its original site to the location it occupies today. Mission documents indicate scarcity of water as the reason. The new location, between two streams, was more secure. The exact location of the original site is still a mystery.

The first order of business was to build a church and other buildings necessary for the efficient operation of the mission. Since the mission was also a school, the design called for a quadrangle of buildings for various activities located around a central square.

Life at the mission was orderly and regulated. Bells tolled at sunrise, sunset and throughout the day as a means of communication. Indians who had become converts to Christianity were assigned various duties in the mission or in the fields.

Priorities were to plant crops and establish herds. Next came housing. In 1794, forty adobe buildings were constructed in four to six rows outside the mission quadrangle. By 1807, thirty-four more had been built to house the grow- ing numbers of people affiliated with the mission. Some of these houses were built around a central square, repeating patterns set in Spain.

The most ambitious project and the one closest to the hearts of Francis- cans then assigned to the mission was the construc- tion of a cathedral, a grand edifice to be dedicated to the glory of God.

George K. Brandriff
The Bells of Old San Juan
Oil on canvas
20 x 24 inches

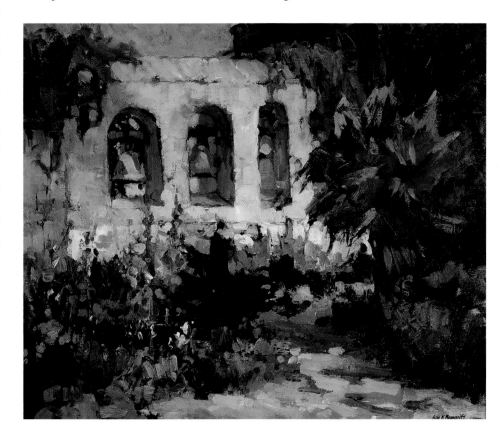

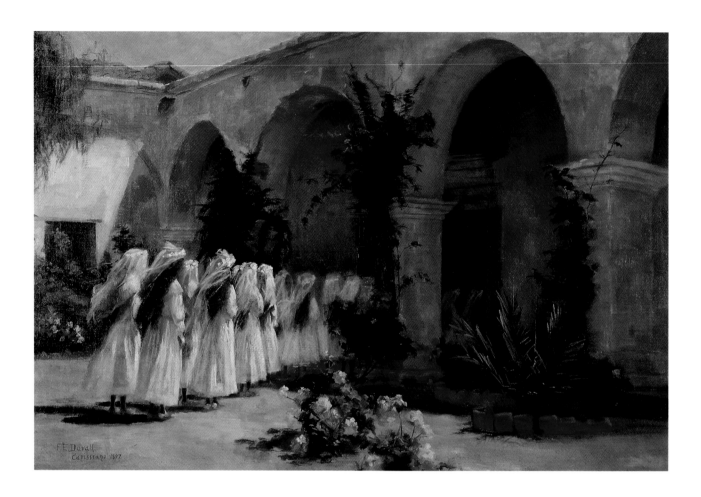

Fannie E. Duvall
Confirmation Class, Mission San Juan Capistrano, 1897
Oil on canvas
20 x 30 inches
Bowers Museum of Cultural Art, Santa Ana, California

In 1797 the cornerstone of the Great Stone Church was placed and work began. A master mason, Isidro Aguilar, was brought from Mexico to oversee the construction. The church was to be built of local sandstone quarried in the hills and rocks brought from the seashore. It was to have seven domes and a bell tower. Work progressed slowly, but was finally completed in 1806. Amid feasting and praying, which lasted several days, the church was finally dedicated.

During the next six years the mission thrived and grew in productivity and in the numbers of souls converted to Christianity. By 1812 mission records indicate more than 1,200 people lived and worked around the mission compound. It was producing 500,000 pounds of wheat, 190,000 pounds of barley, 202,000 pounds of corn, 20,600 pounds of beans, 14,000 cattle, 16,000 sheep and 740 horses. Life was good.

But it didn't last.

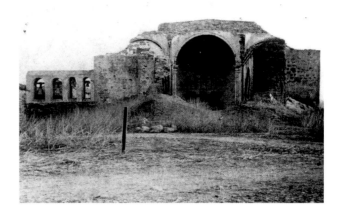

On the morning of December 8, 1812, there was an unusual stillness in the air while many were gathered in the church. They heard it first: a low roar growing louder until it was mixed with screams. The earth shook violently, and the walls of the Great Stone Church crumbled to the ground, releasing the great domes and the bell tower that crashed to the floor. Amid the shock and confusion, the search began for bodies. Several were pulled free. But when the earth stopped trembling and a count was made, thirty-nine people had perished, and the beautiful cathedral, the pride of Alta California, was gone.

Photographer Unknown
Ruins of the Great Stone Church, Mission San Juan Capistrano, c. 1880
Bowers Museum of Cultural Art, Santa Ana, California

Like many human dramas told after a great tragedy occurs, the mission had its story. It was about a young girl named Magdalena.

Magdalena was an Indian girl who lived on the mission grounds. She was in love with Teofilo, an artist, and they would attempt to meet away from prying eyes. Because they were thought to be too young to marry, their love was forbidden. But they defied their elders and were eventually caught.

On December 8, 1812, Magdalena, repentant of her sins and carrying her penitent's candle, agreed to walk in front of the worshippers in the Great Stone

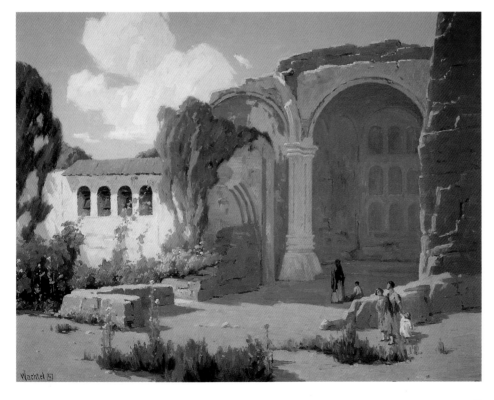

Elmer Wachtel
California Mission (San Juan Capistrano)
Oil on canvas
30 x 40 inches

Church. Suddenly the earth shook and the walls fell to the ground. Among the dead were Magdalena, still clutching her candle, and her lover Teofilo, who had run into the church to rescue her.

On moonlit nights, when the wind is whispering through the leaves, there is sometimes a strange shadow in the window, high up in the ruins of the Great Stone Church. If you look closely, you see the face of a young girl, illuminated by a candle, still doing penance for her forbidden love.

The mission has long been a source of romantic stories, but for the decade after the tragedy, the stark realities of living took over and left no room for romance. The heart of the mission was damaged as severely as its walls, and no one wanted to begin the task of rebuilding the monument that had been such a source of pride.

Life continued although there was unrest in the Spanish colonies. The news from Mexico was always months late, and it was nearly impossible to track events in Spain or South America. But in 1818 the wars of independence being fought a continent away were brought to San Juan Capistrano.

A messenger warned the mission garrison that the pirate Hippolyte Bouchard, representing the United Provinces of Rio de la Plata (Argentina), had attacked Santa Barbara, and the ships were on their way south to attack other Spanish missions. Leaving a small band of soldiers behind as defenders, members of the Mission San Juan gathered the valuables and headed northeast to the Trabuco Rancheria. When Bouchard anchored in the coastal waters off Dana Point, called Bahia de Capistrano, the people of San Juan Capistrano were ready for him.

Bouchard sent a messenger to the mission asking for supplies. The young lieutenant in charge cockily told him that they would gladly provide a supply of "powder and shot."

Incensed because he was badly in need of supplies, Bouchard gathered his men (about 140), two cannons, and marched from the beach to the town. Seeing that they were far outnumbered, the mission garrison fled to the nearest hill and watched while the pirates took over the settlement.

Peter Corney, captain of Bouchard's sister ship, wrote, "We found the town well-stocked with everything but money, and destroyed much wine and spirits and all the public property, set fire to the king's stores, barracks and governor's house, and about two o'clock we marched back though not in the order that we went, many of the men being intoxicated."

Some of the men couldn't make it on their own and had to be lashed to the cannons and dragged to the beach. Six disappeared altogether, using the opportunity to jump ship. When the pirates left, the garrison came back to the mission

to survey the damage. Reinforcements had arrived from Los Angeles but were too late.

The padres and the mission Indians returned, but some of their belongings remained in the nearby hills, safely buried in the ground, hidden from unwelcome visitors and unretrieved by their owners, who couldn't remember where they had put them.

From that day on, rumors of "buried treasure" began to circulate. It didn't matter that the Franciscan missionaries had taken oaths of poverty and didn't own anything, nor did the Indians who resided in the mission settlement. As long as things were missing, they could be as valuable as the searchers made them, and the possibility of discovering riches made the harshest life seem bearable.

Residents returned to the mission after the pirates left, settling back into their daily routines. The mission's prosperous years were behind. Before stretched a blank canvas waiting for form and color. It would come in the new order wrought by the war for independence that Mexico finally won in 1821.

Even before independence from Spain, Mission San Juan Capistrano had begun its decline. Harvests were poor. Conversions were fewer. Indians were leaving and going back to the hills. Stifled by policies which prohibited foreign ships other than those from Spain from trading along its coast, and saddled with land that stretched from Costa Mesa south to Camp Pendleton, Mission San Juan Capistrano had become a victim of neglect. Without support, the mission began to deteriorate and the dream faded beyond redemption.

Alfred Robinson, a visitor to San Juan in 1829, wrote, "This establishment was founded in the year 1776 and though in its early years was the largest in the country, yet it is now in a dilapidated state and the Indians are much neglected."

The attitude of the new Mexican government toward the missions made the situation worse. In 1825 José M. Echeandia became the first native Mexican to become the governor of California. Catholic historian Zephyrin Engelhardt called

Joseph Kleitsch
Capistrano Mission
Oil on canvas
16 x 20 inches
Mr. & Mrs. James Murphy

him "an avowed enemy of the religious orders." One of the manifestations of this change in attitude was the Proclamation of Emancipation, declaring that the Indians should be granted Mexican citizenship and be free from mission control. It also signaled a change in the relationship between soldiers and priests.

That relationship in the missionary period had always been tenuous. Fights over jurisdiction occurred whenever military and clergy had a difference of opinion, generally over a moral issue. Still Mexico was a Catholic country, and in most places priests were respected. Yet San Juan Capistrano became the subject of a huge scandal when in 1832 three soldiers attacked Father Josef Barona as he was leaving the mission, a reflection of the change in attitude toward anything and anyone "Spanish."

In 1833 Governor José Figueroa accelerated the emancipation process. Captain Pablo de Portillo was sent to San Juan to organize the Indian emancipation program, which included distribution of land to settlers and the formation of Indian pueblos. One such pueblo was started in San Juan Capistrano, but it was not a success.

The secularization program was part of a new liberalism which emerged among native-born *Californios*. While not entirely anti-clerical, it did weaken the power of the Church in temporal matters and cut off California's final ties to Spain. It also released the lands owned by the missions to private individuals through the land grant system.

W. E. Rollins
Mission San Juan Capistrano
Oil on canvas
30 x 50 inches

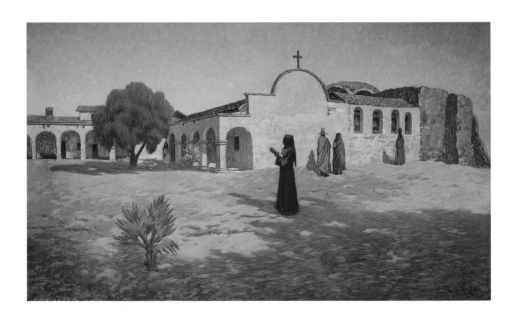

In August of 1834, the government ordered the confiscation of the lands of ten missions, including San Juan Capistrano. Half the land was to go to Indians, and the other half was to be "administered" for the public good. An inventory took place, and the land and buildings of San Juan Capistrano were valued at $56,456. A census found that there were 861 neophytes remaining at the mission. Their choices were grim: they could remain at the mission in a life that was familiar, but which could no longer support them; they could go back to the hills and an uncertain existence in an Indian village; or they could go to the larger pueblos where a life of poverty generally awaited them. According to historian Leonard Pitt, emancipation had created mixed feelings among the Indians. He wrote, "The neophytes were torn tragically between a secure, authoritarian existence and a free but anarchic one. Those who had spent their lives in the shadow of the cross often rejected the preferred liberty, not out of fear of the padres' wrath, but of the uncertainties of the outer world."

California, in that period, was in a state of turmoil. It culminated when Juan Bautista Alvarado declared himself governor in the mid 1830s while officials in Mexico appointed Carlos Antonio Carrillo to be governor. A fight ensued. One of the battles took place near the mission.

Carrillo marched north from San Diego and Alvarado marched south from Los Angeles. Carrillo's men reached the mission first and, not seeing signs of Alvarado, decided to camp there for the night. For some reason, they changed their mind and slept in a nearby arroyo, well out of sight.

At midnight Alvarado's troops arrived, threatening to hang all who did not instantly surrender. When he realized the mission was virtually empty, he and his men settled down to some serious drinking, firing a cannon in a southerly direction just for good measure. This served to awaken Carrillo's troops, who retreated all the way back to Los Flores (on the edge of Camp Pendleton), where they set up camp and mounted three cannons. On April 21, 1838, Carrillo attacked. According to historian Hubert Howe Bancroft, the battle was "for the most part one of tongue and pen, though a cannon was once or twice fired from the corral, doing no harm." Two days later a treaty was signed making Alvarado the sole governor.

The political situation ignored the plight of the missions. San Juan Capistrano, in need of support, received little attention. Its lands were gone, its inhabitants old and infirm. Only Father José Maria Zalvidea remained, seeing to the spiritual needs of the community, while the care and feeding of the mission's inhabitants were left to an appointed government administrator whose duty was to see that crops and animals were tended "for the public good."

By 1840 it was apparent that the Indian pueblo was a failure, either because the Indians had not been properly prepared or because they traded one form of servitude for another. To salvage the situation, William Hartnell was sent by the government to the mission to arrange for the upkeep of the grounds and the care and feeding of the remaining neophytes and the resident priest. He encountered a debt-ridden mission, victimized by robbers and held in low esteem by residents.

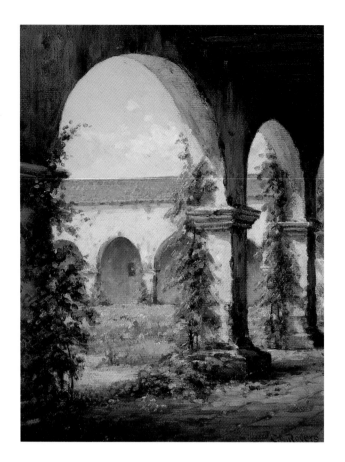

Charles A. Rogers
San Juan Capistrano Mission,
1916
Oil on canvas
12 x 9 inches

The inhabitants wanted old Father Zalvidea to be the administrator, so Hartnell appointed him. But the problems were too severe. After a short time, Augustin Janssens, a Belgian residing on a nearby rancho, succeeded him. Janssens, who had heard rumors of a possible sale of the mission by the Mexican government, forestalled the inevitable by repairing the old water system and fencing the gardens. He even tried to bring back some of the people who had gone to seek their fortunes in Los Angeles. But the effort proved futile. In May of 1841, Governor Alvarado's secretary declared the mission in a ruinous state, and the Indian pueblo dissolved. He then opened the community for settlement by outsiders, granting between 100 and 300 *varas* of land to those who would cultivate it, build a house, and settle. Some of the most prominent families in California staked claims.

The formation of the new pueblo on July 29, 1841, marked an important step in San Juan Capistrano's history. The focus of the community was now turning outward, away from the mission's sun-washed walls and structured environment. The pueblo meant settlers and stores, saloons and stagecoaches—the first trappings of civilization that would alter the future of the community and the mission itself.

The mission was not forgotten in the plan. Proceeds from mission vineyards and orchards would be used to support the resident priest, who would reside in the mission and be in charge of one third of the buildings. Another third would be set aside for use by travelers, and the last third would be used by the Indians who still resided in the mission. Any rents collected would be used for repairs. Tools were to remain at the mission, but could be used by Indian workmen who had the commissioner's permission to do so. Sheep would be cared for by one individual, who would receive a third of the produce for his labors; the rest would be used for weaving.

The first administrator appointed by the government was Juan Bandini, who lasted just over a year. A succession of administrators followed. The job was tough; the town was undergoing a difficult birth. As Bandini characterized it, the community was populated by "drones" who practiced "thieving, drunkenness, and some other deeds deserving to be styled crimes." The settlers who had staked claims did not fulfill their conditions, and properties continued to change hands.

By 1842 Father Zalvidea left, and it was said that people made bonfires of documents and used the buildings of the mission for immoral purposes. By 1845 Mission San Juan Capistrano was nothing more than a debt-ridden burden to its declared owner, the government, and in December, Pio Pico, the last Mexican governor of California, disposed of it.

"Pico, usually overhung with gold chains and jewels, his pockets filled with $50 gold pieces, sold the mission at auction to his brother-in-law, John Forster, and James McKinley for $710," wrote historian Mrs. Fremont Older. Forster later bought out his partner and took up residence in the mission, at the same time becoming justice of the peace. The church was allowed to keep the chapel and one small room for the priest to live in.

Events in San Juan Capistrano soon became overshadowed by events in the territory. War was declared between the United States and Mexico on May 9, 1846. By July the American flag was flying in Monterey. The war officially lasted until 1848 when a broad brush stroke of events, culminating in the signing of the treaty of Guadalupe Hidalgo, officially ceded California to the United States. By 1850 California was a state.

Pico's departure from California was a boon for Forster, who lived in the mission. He took control of his brother-in-law's Rancho Santa Margarita y Los Flores, adding it to the other ranchos he already owned. He remained at the mission, living in what is today the gift shop, although his care of it did not impress visitors. Horace Bell, in *Reminiscences of a Ranger or Early Times in Southern California* described the place as "old, dilapidated, vermin-infested, tumbling down mission buildings," with only Forster's living quarters as habitable.

The town itself was making progress but still suffering growing pains. It was a small frontier town plagued by squatters, drifters, bandits and cowboys. But signs of stability were evident. The mission stood firm at the north end of the plaza in defiance of the wind, rain and neglect that threatened its survival. A row of adobes on either side of the town square formed the east and west boundaries of the settlement, with additional huts and adobes scattered along the banks of the rivers. There was activity in the square on market days and brawling in the saloons at night. Crops continued to grow, and merchants came to town to conduct business. There was even a traveling judge to mete out justice when the need arose.

Despite the changes in the fortunes and ownership of the mission, it still symbolized refuge for many. This was illustrated in 1857 when the town was besieged by bandits.

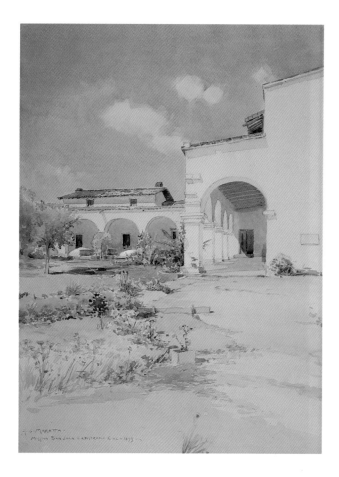

H. G. Maratta
Mission San Juan Capistrano,
1899
Watercolor
22 x 16 inches

In the early winter months of 1857, Juan Flores, a convicted horse thief, escaped from San Quentin. As he made his way to Southern California, he gathered the remnants of his gang. By the time he reached San Juan Capistrano, the gang, called "Las Minilas," numbered around fifty.

Flores stopped in San Juan to visit his girlfriend Martina, who was the housekeeper for the shoemaker Tomás Burruel. Heading for Mexico, Flores was badly in need of guns and ammunition, and only one place in town had the arsenal he required. It was the store of George Pfleugardt, a merchant who occupied the two-story Garcia Adobe, still standing in downtown San Juan.

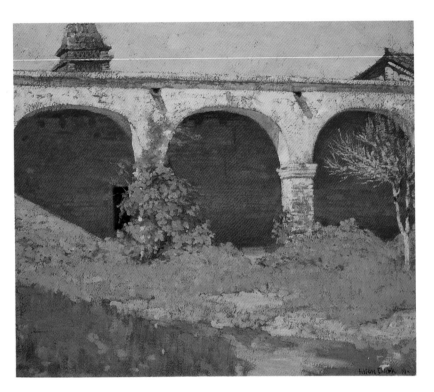

Alson S. Clark
San Juan Capistrano
Oil on board
15 x 18 inches

Before invading this well-tended bastion, Flores' gang tried to obtain a weapon or two from another shopkeeper, Miguel Kraszewski, whose establishment was on the plaza near the Burruel Adobe. Three gang members wandered into the store, browsed for awhile, and took a pistol without paying. Kraszewski ran after them, shouting for them to return. A few minutes later the entire gang returned with pistols drawn and surrounded the store. Kraszewski and a customer, Librido Silvas, bolted the front door and held the side door closed until a bullet splintered the wood and grazed Silvas' hand. They ran to hide, covering themselves with big Spanish baskets while the bandits broke down the door. After plundering the store, they left, only to return, causing more havoc in the streets. Most of the townspeople fled to the mission where they took refuge in Forster's quarters. At one point Forster decided to go out and try to calm people, but his family and several others who had run to the mission for protection persuaded him to remain indoors.

The bandits stayed in town, littering the streets with stolen goods, not letting anyone in or out. Those sequestered in the mission had a good view of the action and watched it through the night.

Having stolen goods from Miguel Kraszewski and Henry Charles, another plaza storekeeper, Flores had only Pfleugardt's establishment left to loot. Knowing he would not be able to get in on his own, Flores sent Martina to the front door after hours. She told Pfleugardt she was there to redeem a shawl which she had pawned. Standing in the doorway, she lit a small, hand-rolled cigarette, which was the signal for the bandits. They kicked in the door. Flores took aim over Martina's shoulder, killed the merchant and robbed the store.

Small in number and helpless to halt the actions in the town, the group at the mission watched in horror. Among them was an American, Garnet Hardy, who once had Flores arrested for horse theft and well knew what his fate would be if discovered. He took a chance on escape and was able to make his way to Los Angeles where he contacted Sheriff James Barton. En route to San Juan with a small posse, the sheriff and his men were ambushed and killed by the gang, who had learned of their impending arrival. Two large posses were then sent to hunt down the killers.

The bandits fled to Saddleback Mountain and were eventually caught, singly or in groups. Some were hanged on the spot, while others were taken to the city to stand trail.

Flores, who was only twenty-two years old, was caught, escaped, and was caught again. He was taken to Los Angeles but did not stand trial. Shortly after being interviewed by the local newspapers, he was escorted from his cell and hanged at public execution in front of a large crowd. It was February 14, 1857.

Life in San Juan Capistrano continued at its normal pace, and although there was petty thievery, no large incidents occurred. But change was on the horizon, change so sweeping and so final that it would etch a new era in San Juan's history.

After California became a state and the effects of the Gold Rush were spilling over into every corner of the state, a new tribunal was formed called the United Sates Land Commission. The purpose of this body was to determine ownership of land. But instead of assuming ownership until a challenger prevailed, the Commission invalidated all of California's existing property ownership and decreed that each person must prove his right to his land before he could gain title. While giving an advantage to those filing gold claims in the North, this pronouncement threw Southern California land titles into a collage of formless squabbling. Those without documentation lost. Those with documentation eventually prevailed, but the cost was so great that land was lost anyway. One man who gained from the process was Bishop Joseph Sadoc Alemany, the Bishop of San Francisco, who used the opportunity to invalidate the right of the Mexican government to sell the missions. Among those that were returned to the Church was Mission San Juan Capistrano.

Forster, upon hearing the news, vacated and moved his family to Rancho Santa Margarita (to the home occupied today by the Marine Commandant of Camp Pendleton). The official document granting the return of the mission buildings and five small tracts of land surrounding it was signed by President Abraham Lincoln just a few months prior to his assassination.

But even those who rejoiced in the return of the mission could not be happy with the situation around them. Rancheros, decimated by the costs of defending their titles, took further abuse by the elements. First came the torrential rains of 1861, which turned roads into quagmires and caused disastrous floods. Next was the drought of 1862, which persisted until 1864. From the drought came the loss of thousands of cattle and the deaths of hundreds of workers who had contracted smallpox.

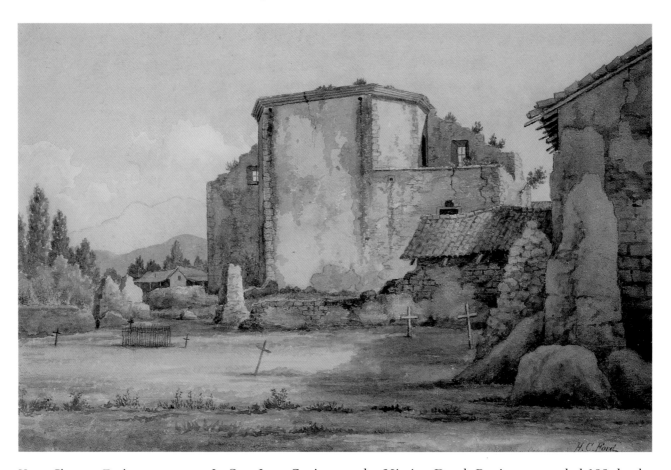

Henry Chapman Ford
Rear of San Juan Capistrano Mission, from the Cemetery
Watercolor
12 1/2 x 19 1/2 inches
The North Point Gallery,
San Francisco

In San Juan Capistrano the Mission Death Register recorded 129 deaths between November 16 and December 31 of 1862 – all Indians. Letters indicate that six to eight people a day were stricken during the height of the disease, and trenches had to be dug to bury the dead in common graves. In total, about two hundred people died in San Juan during the two-year period.

There is a story that the disease was introduced by sailors who had unloaded a shipment of redwood destined for the Canedo Adobe (once located on the southeast corner of El Camino Real and Ortega Highway). The owner, Salvador Canedo, had wanted to make improvements to his home. But the sailors who brought the shipment of wood were sick, having stopped in Santa Barbara where smallpox already raged. The improvements were made, but Salvador Canedo did not live to enjoy them. He too died of smallpox, and his home became a place where wakes were held for the dead.

In the 1860s a new order emerged based on diversified farming. Settlers who came west to escape the ravages of the Civil War found land was available for purchase. The great ranchos, staggering under debts, were broken up into smaller parcels, and a new social system based on a greater number of smaller farms emerged in what would one day be Orange County.

The town of San Juan Capistrano flourished. Halfway between Los Angeles and San Diego, it became a stopping place for travelers. Tourist amenities such as eating places and humble hotels were established. By 1876 the town boasted a schoolhouse, telegraph office, post office, two stores, hotel, four saloons and forty or fifty homes, mostly of adobe. It also had a stage stop and a resident priest, though he did not reside in the mission.

The mission, a tragic relic of past glories, stood at the north end of the community, a colorful, crumbling ruin which cried out to the sketch pads of fashionable people who broke their journey in the sleepy little town. Weeds had grown in the corridors and central quadrangle, animals roamed freely through open doorways, and birds nested in the remains of roofs which had caved in through neglect. It was a poignant reminder of broken dreams but not of a broken spirit. The mission survived — unprotected, unsupported — but it was there. And it was still the focal point of the community.

Anna A. Hills
Ruins of the Chapel, Capistrano
Oil on board
7 x 10 inches

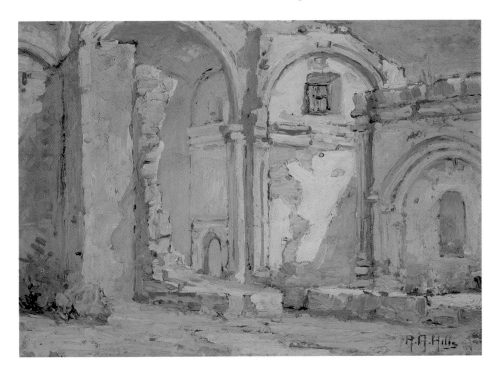

59

In 1887 the railroad pushed through, creating a more efficient means of getting products to markets. The mission lay abandoned; peacocks roamed the weed-filled corridors, piercing the stillness with their anguished cries. Father José Mut, the last resident priest, had left in 1886. But the mission still had a special attraction, especially for artists and photographers who found themselves wandering its rock-strewn pathways, enjoying the new peace it wore. It was not without activity. People needing wood beams for their houses or stones for their foundations generally took them from the mission. Even the roof tiles were plundered, with many of them used on the roof of the new train station built in 1894. But the mission was about to get a guardian, a champion who would defend its honor and its right to be left intact. It was Charles Lummis, president of the Landmarks Club of Southern California, who in 1895 made Mission San Juan Capistrano his personal project.

Abhorring the plight of the missions, Lummis used his considerable influence to put an end to their deterioration. Selecting San Juan Capistrano as his first project, Lummis was able to attract monied interests and a group of stalwart volunteers who halted the mission's decline. The weeds and debris were removed from the grounds, two intact sections of the mission quadrangle were stabilized, and the arches and colonnades were shored with stout wooden beams. Workers also repaved 5,250 feet of walkways with asphalt and gravel, repaired holes in adobe walls, and secured what was left of the Great Stone Church. Not only did they remove several tons of debris, they also provided enhancements by planting a garden, installing an irrigation system, and adding a few trees to shade the mission's aging countenance. When the work was completed, they moved on to do similar work at San Diego, San Fernando and Pala.

"It is no exaggeration to say that human power could not have restored these four missions had there been a five year delay in the attempt," wrote Lummis.

Locally, the work was supervised by Judge Richard Egan. Of particular concern was the control of treasure hunters who dug holes on the grounds on a regular basis and who had totally undermined a nearby adobe in their zeal.

Judge Egan, whose brick home, called Harmony Hall, still occupies its original site on Camino Capistrano, was the right choice for unofficial caretaker of the mission. Having supervised the work financed by the Landmarks Club, he was one of the undisputed town leaders. He counted many notables among his friends, including the famous actress Madame Helena Modjeska, who liked to visit her friend whom she called the "King of Capistrano" and who found relaxation by sitting for hours in front of an easel painting the mission. Perhaps her paintings were displayed at one of the local art shows given during the 1890s, a period that was characterized by outdoor concerts, dances, picnics, and lavish dinners.

The railroad had brought San Juan Capistrano into the mainstream of culture and commerce, and it had also become a destination for those seeking the healing waters of the San Juan Hot Springs resort. While waiting for the buggy that would transport them on the thirteen mile journey eastward, many tourists were drawn to the mission. Odell Shepard, writing in the *Overland Monthly*, caught

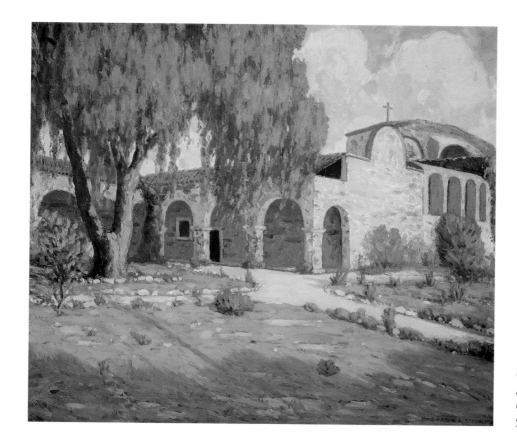

Charles L. A. Smith
San Juan Capistrano Mission
Oil on canvas
25 x 30 inches

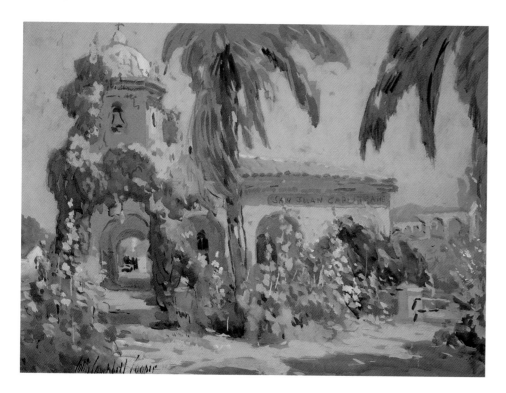

Colin Campbell Cooper
Capistrano Train Station
Watercolor
11 x 14½ inches

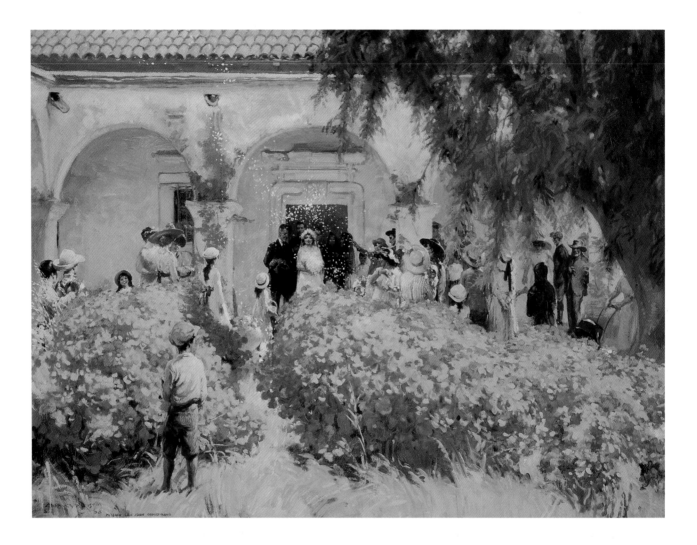

Charles Percy Austin
Mary Pickford's Wedding,
Mission San Juan Capistrano,
1924
Oil on canvas
36 x 48 inches
Mission San Juan Capistrano

the essence of what compelled them: "The mission buildings on one side of the immense quadrangle dominate the view of the town as completely as they do also the thoughts of the townsfolk and visitors alike." He noted that San Juan, unlike most towns in America, gained its significance and importance from its past rather than by what might occur there in its future.

"One gains a new respect for the concentrated energy and the personal power and devotion of the padres when he sees how their influence prevails after all the years over the alien populations that they gave their lives to serve," he said.

Shepard was not the only one to be drawn by the mission's magnetism. Those whose job it was to spin fantasies and transform drab existences into exciting adventures also found the mission to be an attractive location. One such group arrived in town in March of 1910.

It was raining on the night that three railroad cars pulled onto the siding at the Capistrano Depot. The occupants of the cars—employees of Biograph Studios—had arrived to film *Two Brothers*, the first film ever made in Orange County. Among them were the director, a man who would become a giant in the film industry, and his leading lady, a petite 17-year-old with a heart-shaped mouth. Their names were D. W. Griffith and Mary Pickford. Their destination was the mission.

The Biograph production crew took over the old Mendelson Inn, which once stood in a now-vacant lot on El Camino Real in San Juan Capistrano. For three days the rain continued, and the shooting could not begin. The crews sat around with nothing to do while the director paced and checked weather reports. The only diversion was a traditional San Juan funeral procession which passed near the hotel on foot en route to the cemetery.

The fourth day the sun came out, the actors left the hotel in the colorful early California costumes called for by the script, and the first scene was shot—an Easter procession on its way to the mission. Interested in the activities of the strangers, a large crowd gathered, but interest soon turned to dismay. The crowd, not knowing anything about the script, thought the actors were mimicking the funeral held the day before. They became very angry and surged forward toward the actors and the crew, who ran for the safety of the hotel.

Mr. Griffith had not foreseen this problem and had to rely on the hotel proprietor to explain the scene to the mob and calm everyone down. He also volunteered to have his cowboys (who were fortunately former rodeo performers) put on a riding and roping exhibition, which pleased the crowd and allowed filming to resume.

There were many more films using the mission for its primary scenes. One of the most memorable of the silent films made in San Juan was Douglas Fairbanks' *The Mark of Zorro*. Adapted from a magazine article by Johnston McCulley, the movie was based on a story originally named "The Curse of Capistrano."

The mission was not immune to changes around it, but it needed a catalyst to spring it into the twentieth century. This came in the form of a quiet, gentle man who stepped off a train in 1910, walked to the mission, and saw the place that would change his life. His name was Father St. John O'Sullivan.

O'Sullivan explored the grounds, peering into ruined halls and pits, sifting through piles of stones, and learning all he could about a place that for him held utter fascination. He also began to dream, to see the mission not as it was, but as it could be with a little care and attention.

Father O'Sullivan devised a plan and infused townspeople with the energy to carry it out. The mission was their legacy, he would say. It must be cherished and passed on to others. To give physical shape to his ideas, he supervised the production of adobe bricks to rebuild crumbling walls; he organized visits to the nearby Santa Ana Mountains, where trees were cut and beams were carved by hand. He planted gardens that would burst into jewel-like color in the spring and summer, and he planted trees to shade the walkways. But his major concern was Father Serra's chapel, which was stabilized but unrestored. It was needed by the parish which, since the 1890s, had been using Forster's old living quarters as the mission church. To fund the project, he began charging admission to those wishing to view the magnificent ruins.

Untiring in his efforts, O'Sullivan enlisted the aid of prominent Orange County residents to help with fund-raising. Walter Knott, Fred H. Rupell,

Joseph Kleitsch
Portrait of Father John O'Sullivan
1924
Oil on canvas
30 x 25 inches
Mission San Juan Capistrano

Gutzon Borglum, and Roger B. Sherman helped with the plans. Soon the mission was a destination for tourists, who grew in increasing numbers, thanks to new mobility provided by the automobile and to media interest in the little project in San Juan Capistrano.

An admirer of Father Serra, O'Sullivan conceived the idea of erecting a statue to his memory. Gutzon Borglum was commissioned to do the work, and local people stood as models. The statue was dedicated August 13, 1914, and for a time stood at the mission's entrance. Today it stands permanently near the bells.

O'Sullivan's crowning achievement was the successful restoration of Father Serra's Chapel, the only church remaining in California in which Father Serra said Mass.

Photographer Unknown
The Padre's Garden, Mission San Juan Capistrano, c. 1910
Bowers Museum of Cultural Art, Santa Ana, California

When O'Sullivan arrived, the chapel was being used as a lumber warehouse. Before that it was used to house olives, wool, barley, and several buff-colored owls. In 1922 the restoration began using old construction methods and thick adobe bricks. When completed, the sanctuary was decorated with objects from the Great Stone Church. Some pictures, candlesticks and statues had apparently survived the earthquake and had been preserved on the premises.

The main altar had all but disappeared. Father O'Sullivan found a Baroque retablo in storage in Los Angeles and was able to acquire it for the Serra Chapel.

The beautiful retablo had been sent to Los Angels from Barcelona, Spain, in 1906, and placed in storage. It came in fragments, 396 in number, and was packed up in ten large boxes.

The age of the retablo was uncertain, but it was believed to be several centuries old. It was made of cherrywood with a covering of gold leaf. It was placed where a clerestory window bathed it in light. "Viewed through the hundred foot long nave of the church, which is usually in semi-darkness, the sight is one not easily forgotten," O'Sullivan wrote.

Father O'Sullivan's fund-raising efforts continued. He enlisted the help of Garnet Holme, author of the play *Ramona,* to write a pageant which could be produced on the mission grounds. He wrote a small book called *Little Chapters About San Juan Capistrano* to tell the mission's history to interested tourists, and he opened the mission grounds to artists, who flocked there during the plein-air period to take advantage of the fantastic light, the mysterious atmosphere, and the brilliant colors of the garden.

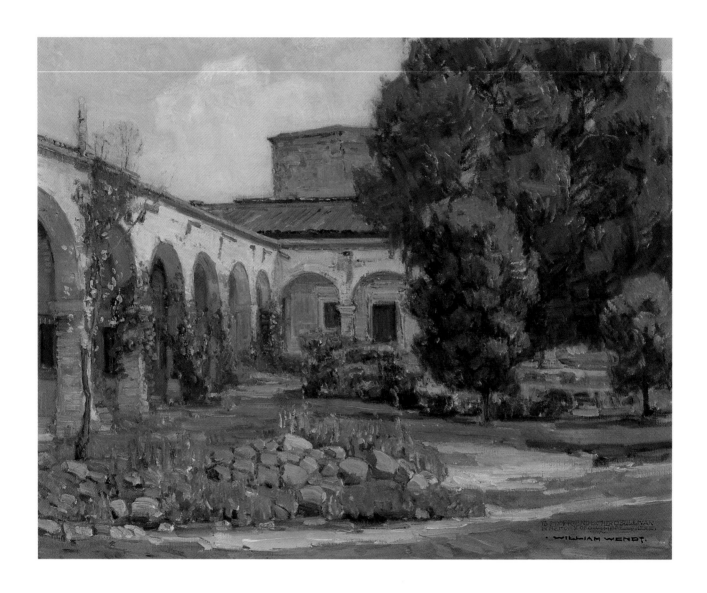

William Wendt
Mission San Juan Capistrano,
(dedicated to Father O'Sullivan)
Oil on canvas
24 x 30 inches
Collection of Tony Moiso

Many famous artists painted the mission, some staying for long periods of time at one of the hotels or as guests of townspeople. Others never gained particular recognition, but were nevertheless unique in their own right. One was Captain Vladimir Perfielieff of the Imperial Russian Army—soldier, diplomat, explorer, and artist.

Captain Perfielieff, who studied art in Philadelphia and at Princeton, was well-known around the community. He lived in the Hotel Capistrano, paid his bill often in paintings, and was considered a good art teacher and a good story-teller. Characterized as "an Eagle living like a Sparrow," he ended his days in Laguna Beach, but his existence in San Juan was typical of many who came to visit and ended by staying.

Father O'Sullivan enjoyed having artists around. He also cultivated writers. One of his favorites was Charles Saunders, with whom he wrote a book called *Capistrano Nights*, which told some of the legends and folklore associated with the mission.

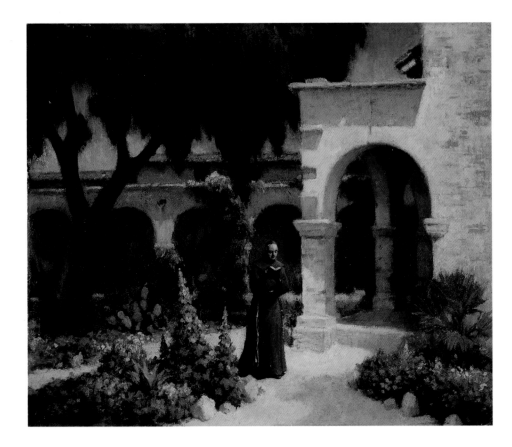

Charles Percy Austin
Padre Reading, Mission San Juan Capistrano, (presented to the Mission by the artist)
Oil on canvas
20 x 24 inches
Mission San Juan Capistrano

The mission's age and emptiness at night gave many imaginative visitors a sense of eerie expectation, like someone waiting just around the corner, someone you might not want to meet. One such legend told of a faceless monk who haunted the dark corridors of the original quadrangle and was always seen scurrying away. Another ghost was a headless soldier, a mission guard who stood near the front entrance. But the best loved spirit was the young girl named Magdalena who had died in the earthquake of 1812.

Sydney Laurence
The Evening Star,
Mission Capistrano
Oil on canvas
20 x 16 inches

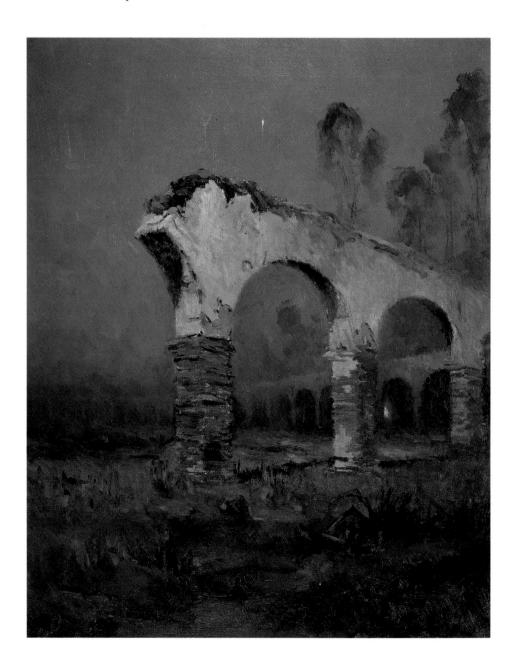

While ghost stories were immensely popular in the town, the most famous story associated with the mission is one about birds.

Swallows had been coming to the area for centuries, nesting in the cliffs off Dana Point and San Clemente. When the mission was constructed, they began nesting in its eaves, since it was made of mud, the same material swallows use to build their nests. While there is an early reference to swallows in one of the annual reports of the mission from the 1790s, they apparently became such a natural part of the mission that they went unnoticed. A magazine writer visiting the mission in 1911 noted their presence, but nothing more is mentioned about them until 1930 when Saunders and O'Sullivan published their book, which included a story about the swallows.

"By the way, there is a very odd fact about these swallows," said Father O'Sullivan. "You know they migrate every autumn, but their return is with the greatest regularity on St. Joseph's Day, the nineteenth of March. Within a few days they set about patching up their broken nests, building new ones, and disputing possession of others with such vagrant sparrow families as may have taken up illegal quarters there during the swallows' absence."

We know today that swallows migrate from Argentina and Brazil. The swallows' return captured the imagination of many writers, including Ed Ainsworth, a columnist for the *Los Angeles Times*, who dutifully noted the return of the swallows every March 19, St. Joseph's Day. His story was reprinted or restated by other journalists all over the country. The swallows became a symbol of stability in the 1930s when reality, for most, was grim. In fact, they were so much fun that a national broadcast was held on the mission grounds each year, just to await the swallows' return.

On March 19, 1939, a songwriter named Leon Rene was having difficulty with an assignment. He was impatient for his breakfast, and came out to the kitchen to grumble a bit at the time a radio announcer was commenting that the swallows had not yet arrived. He made a sarcastic remark to his wife that he bet he would have to wait until the swallows came back to Capistrano before he saw his breakfast. The remark gave him an idea, one that resulted in a song, "When the Swallows Come Back to Capistrano," which was recorded by popular singers of the day and is still well remembered.

Father O'Sullivan, who helped make the swallows famous, died in 1933. He is buried on mission grounds.

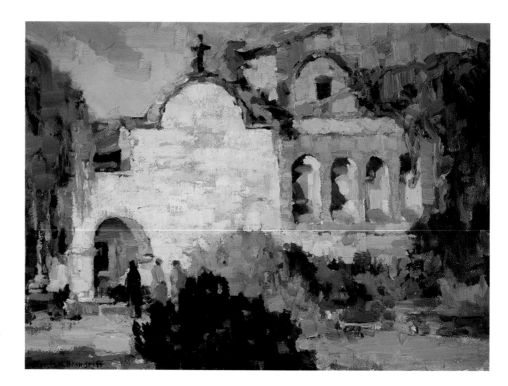

Right:
George K. Brandriff
Capistrano Mission
Oil on board
13 x 18 inches

Below:
Mission San Juan Capistrano,
1994
Photo by Casey Brown

Artists still capture the essence of the mission for the world, sharing it with art museums and private collectors. And visitors come to the mission in increasing numbers, about 400,000 a year including over 80,000 school children.

But there is a continuing struggle that at times seems overwhelming—it is the battle against the elements. The mission is essentially a mud-adobe structure

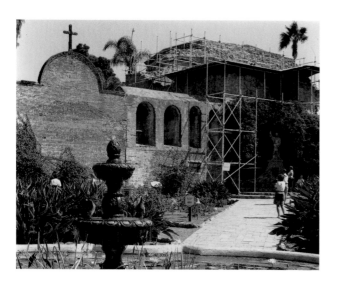

built without the aid of modern technology. A portion of the Great Stone Church still stands, but time and erosion are eating away at what is left, and there is the fear that another earthquake might tumble it to the ground. The mission has launched a preservation project to address the most urgent needs. A plan has been developed, scaffolding has been built to keep fragile walls intact, and fund-raising is being intensified. Work is slow, but progress is being made.

As the mission moves forward in its third century, it is still a showplace not to be missed. The swallows still come back, visitors are on the increase, and artists still come to paint and dream and interpret.

It is a place of giving.

It has given pride, character, and definition to the community that bears its name. It has given a legacy to those who come to share its history and its legends. It has given sanctuary to those who seek peace in a world that is sometimes overwhelming.

Behind the walls are the colorful gardens and time-worn pathways that lead to peaceful fountains, the lights and shadows of pillars and corridors still musty with age. If you look over your shoulder, perhaps you'll see the skirts of some long-departed Franciscan disappearing around a corner. If you listen intently, you might hear the laughter of Indian children playing in the quadrangle. If you sit on a bench in the rear of Serra's chapel, you can easily transport yourself back into another era when life was regulated by the sound of a mission bell and cares were left in the hands of God.

Mission San Juan Capistrano is at peace with itself as the "Jewel of the Missions" moves proudly into the future.

Photographer Unknown
Mission San Juan Capistrano,
c. 1900
Hand-tinted photograph
Mission San Juan Capistrano

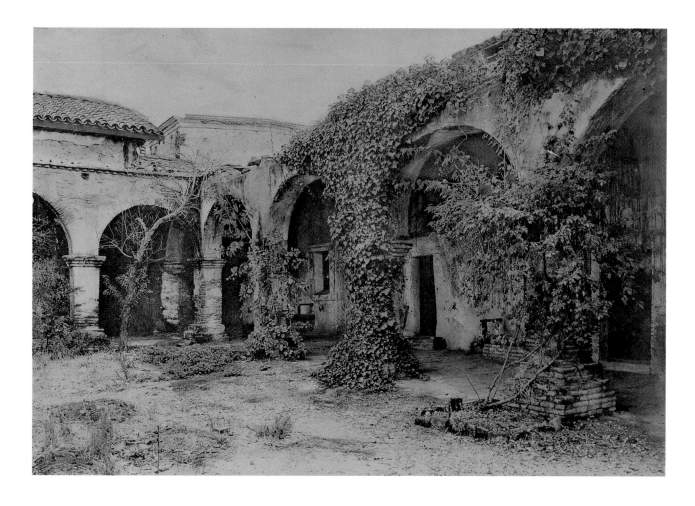

Charles H. Harmon
San Luis Rey
Oil on board
30 x 46 inches

Art in California: 1880 to 1930

by Jean Stern

The earliest images of the California missions occur in the late 1700s as rare paintings and sketches made by visiting explorers or artists who had endured a long and arduous voyage to reach California. With time and changes in political jurisdiction, the missions became more attainable to artists, especially after California became a part of the United States in 1850. By the 1880s artists were regularly painting and sketching the more accessible missions, which by then were in ruin or abandonment. The crest of popularity for the California missions in art came in the first part of the twentieth century, between 1910 and 1925. Those years saw California experience tremendous growth in population and, with that, unprecedented increase in numbers of tourists, many of whom were fascinated by the missions. New roads and affordable travel had made these historical monuments easily accessible for day-trips. At the same time, awareness of the historical role of the missions and the need to save and restore them sparked an intense concern in the circumstances of the missions. Artists of this period found the missions to be romantic and heroic subjects for their paintings, at the same time realizing that tourist demands for mementos of California made mission paintings quite salable. The results were large numbers of beautiful and historically accurate renditions of the California missions in the artistic style that defined California art at the time.

In the 1860s and 1870s, at the time that Impressionism flowered in France, California was yet a distant, isolated region, hazardous and time-consuming to reach. The initial transcontinental railroad, the Union Pacific, was completed in 1869 with its western terminus at San Francisco. Prior to the completion of the Union Pacific, the only approaches to California were overland by horse and wagon through hostile territory or around South America or by ship from Panama. The pre-canal Panama route necessitated docking on the Atlantic side, crossing the isthmus to the Pacific side and boarding a ship to continue to California.

From the onset, San Francisco was the center of American social and intellectual presence in California. The first influx of American artists in California came with the Gold Rush. They produced narrative works of life in the gold fields as well as still-life and topographical views of San Francisco. Eventually, they found patronage with the social elite of San Francisco, and by the latter part of the nineteenth century the dominant art style in California was French inspired, with landscapes that relied heavily on influences from the Barbizon School. The best known of these San Francisco Barbizon painters was William Keith (1839-1911), whose paintings are often moody, late-in-the-day pastorals with somber tones and darkening shadows of deep browns.

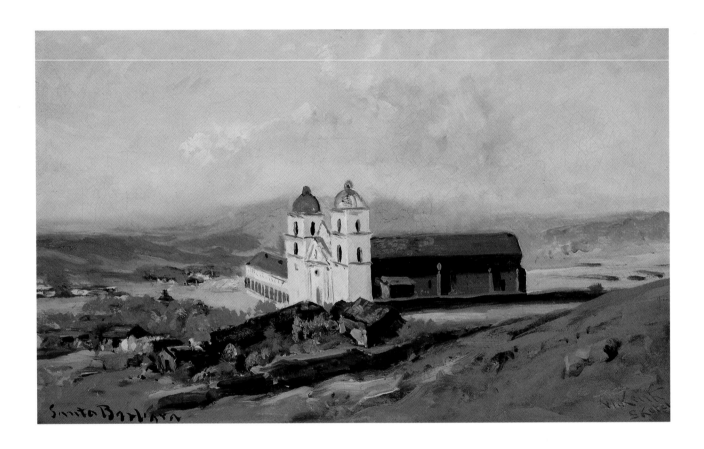

Above:
William Keith
Santa Barbara Mission, 1883
Oil on canvas
16 x 26 inches
Montgomery Gallery,
San Francisco

Right:
William Adam
*San Carlos Mission from the
Laguna, Monterey,* 1909
Oil on canvas
14 x 24 inches
Collection of
Terry & Paula Trotter

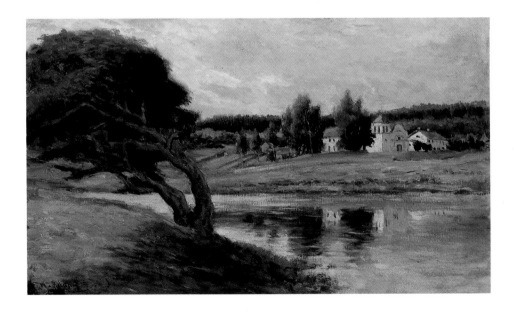

Starting with the late 1880s and continuing into the early part of the twentieth century, artists working in California produced an artistic style which focused primarily on the boundless landscape and unique light of this Golden State. This style, which is often called California Impressionism or California plein-air painting, after the French term for "in the open air," combined several distinctive aspects of American and European art.

As a regional variant of American Impressionism, the California plein-air style is an amalgam of traditional American landscape painting with influences from French Impressionism. It is part of the continuum of American art's passion with landscape, a lineage that began with the early years of the American Republic and, during most of the nineteenth century, found its greatest expression in the works of a group of artists known as the Hudson River School. This group of landscape artists, led by Thomas Cole (1801-1848) and Asher B.

Alson S. Clark
Summer Day, Overlooking the San Diego Mission
Oil on canvas
26 x 32 inches
The Fieldstone Company

Durand (1796-1886), ventured into the "wilderness" of upstate New York. They were in awe of the beauty and grandeur of nature and developed a popular and long-lived style that centered on landscape as a primary subject.

At the same time, America nurtured a vigorous school of painters who recorded the "ordinary things" of American life. These genre painters, most notably Winslow Homer (1836-1910), specialized in scenes of everyday life in a country that, at the time, was perceived as a land of farms and small towns.

The tradition of American landscape painting is inseparable from the American spirit. Indeed from Colonial times, American had been governed by two dominant factors: the absence of religious patronage and a penchant for portraying the everyday character of American life. Landscape painting was an ideal vehicle in both cases, as it afforded an avenue to express God and Nature as one, an understanding of spirituality that disavowed religious patronage; and it created a metaphor of the American landscape as the fountainhead from which

sprang the bounty and opportunity of rustic American life. In both circumstances, the artist's objective was for careful and accurate observation; thus Realism and its associated variants was the style of choice. The desire for realistic portrayal of forms has always been associated with American art.

Towards the middle of the nineteenth century, a widespread and forceful artistic movement swept across Europe. That movement was Realism. Realism's purpose was to give a truthful, objective and impartial representation of the real world based on meticulous observation of contemporary life.

The French were quick to adopt and popularize Realism. As practiced by Gustave Courbet (1819-1877) and Jean Francois Millet (1814-1875), it became associated with social activism and thus met with considerable resistance among the French art community.

In France, a prominent aspect of Realism was directed towards nature and embraced its social mission by emphasizing life in the rustic settings of France. Coming at the height of the adverse consequences of the Industrial Revolution with its attendant mass urbanization, environmental pollution and social transformations, Realism repudiated the urban environment and harkened to the idyllic life of the immediate past, to a time, real or imagined, when people were in harmony with nature and its bounty. It was a movement to democratize art, affiliated with other mid-century demands for social and political democracy.

Declaring that art must have relevance to contemporary society, the Realists refused to paint moralistic or heroic models from the past and instead directed their attention to themes that acclaimed people and events in more commonplace circumstances and in their own time. In that vein, Millet, who painted the daily life of the French farmer, promoted an idealistic and romantic model emphasizing the dignity of peasant life. While Millet favored figural scenes over pure landscapes and chose the farm as his subjects, he nonetheless worked in a studio and painted from posed models.

Carl Oscar Borg
Mission San Fernando
Oil on canvas
20 x 30 inches
Dr. & Mrs. Edward H. Boseker

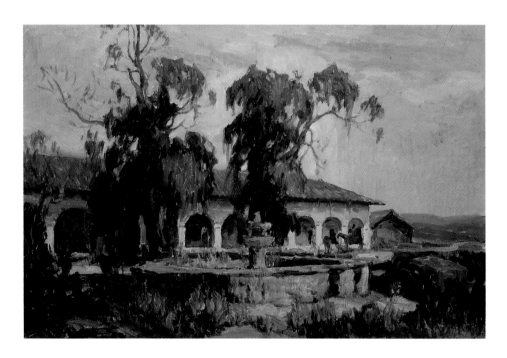

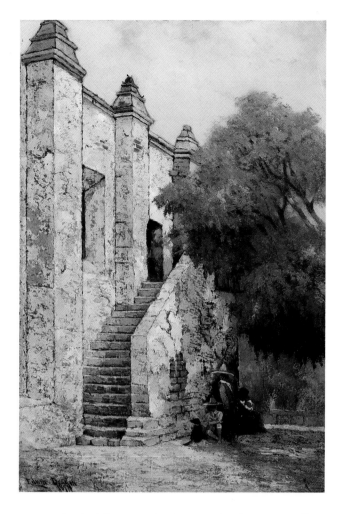

Edwin Deakin
The Stairway,
Mission San Gabriel
Oil on canvas
18 x 12 inches

Virgil Williams
Padre's Porch,
San Gabriel Mission, 1885
Oil on canvas
24 x 18 inches
Dr. & Mrs. Edward H. Boseker

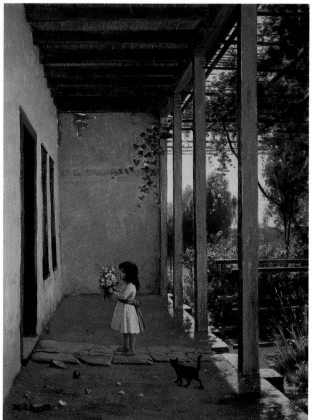

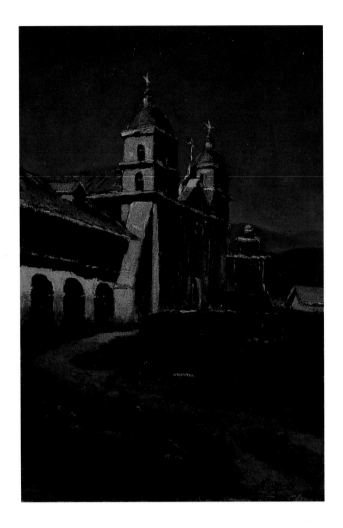

Manuel Valencia
Santa Barbara Mission at Night
Oil on canvas
30 x 20 inches
De Ru's Fine Arts,
Bellflower, California

Theodore Rousseau (1812-1867) and Charles-Francois Daubigny (1817-1878) were among a group of Romantic-Realist painters who specialized in landscape painting. They imbued their works with a dramatic sense of light, most often energizing their compositions with vivid end-of-the-day sky effects. These plein-air artists lived and painted in the village of Barbizon, thus giving name to this aspect of Realism, a romantic model of people and nature, handled with a broader stroke and coupled with dramatic lighting. The Barbizon style found a quick and willing group of followers in late nineteenth-century Europe and America.

The art of painting underwent a revolution starting in the 1860s. The cumulative result of a systematic study of light and color, coupled to a rising interest in scientific observation and the preference by artists for on-site plein-air painting, modified the age-old effort of trying to capture or duplicate the true, natural representation of light to that of representing the *effect* of light in terms of an optical stimulus/response sensation.

This revolution in art was spurred by numerous scientific color theories that were circulated in the latter part of the nineteenth century. This trend was manifested by newly published scientific investigations of physiological optics and, most importantly, in the active involvement of the artists in these fields. The artistic inheritors of this revolution were the Impressionists in the early 1870s and, more so, the Neo-Impressionists in the 1880s.

Among the many color theories that influenced art in the late nineteenth century, the most popular were those of Eugene Chevreul, originally published in French in 1839, with an English translation appearing in 1872. Chevreul was a consulting chemist who was asked to improve the quality of dyes used in a tapestry factory. He conducted many experiments, looking for ways to produce colors that were more vivid. He deduced that the role of the chemist was not as important as the role of the artist, and that more potent dye formulations would not significantly improve results as effectively as proper color placement. Thus evolved Chevreul's Law of Simultaneous Contrast of Colors. It states, in part, "The apparent intensity of color does not depend as much on the inherent pigmentation... as it does on the hue of the neighboring color." Furthermore, Chevreul states, "When

two colored objects are scrutinized together, the color of each will be influenced by the complementary color of its neighbor." Moreover, "In the case where the eye sees at the same time two contiguous colors, they will appear as dissimilar as possible, both in their optical composition and in the height of their tone."

Chevreul's work was truly revolutionary because it was based on recent advancements in the scientific study of physiological optics. His law explores the role of color as a stimulus on the human eye, not necessarily on its role in nature. He advised the artist to realize that, "There are colors inherent to the model which the painter cannot change without being unfaithful to nature (and) there are others at his disposal which must be chosen so as to harmonize with the first." In addition, he cautioned, "The greater the difference between the colors, the more they mutually beautify each other; and inversely, the less the difference there is, the more they will tend to injure one another."

A variety of scientific theories of color were quickly accepted and systematized by the Impressionists in the early 1870s and to a greater degree by the Neo-Impressionists, followers of Georges Seurat (1859-1891), in the 1880s. The immediate outcome of this scientific infusion in art was the appearance of intensely bright paintings, particularly in sunlit outdoor scenes. The utilization of the previously discussed laws of color contrast and color harmony enabled the artist to present the effect of intense sunlight and, at the same time, the effect of cool, lively shade without arbitrarily darkening the shadow. Overall, the impressionist painting was designed to create movement on the optical plane by the juxtaposition of selected color patches, a movement which closely approximated the natural fluidity of light.

The concerns of artistic methodology and preference of subject matter caused the Impressionists to part company with the Realists. Technically speaking, the Realism of Courbet and the Romantic-Realism of Daubigny were, in effect, academic approaches, differing only in subject matter and objective content.

Ross Dickinson
Mission by Moonlight (Santa Barbara), 1930
Oil on canvas
24 1/4 x 30 inches
William A. Karges Fine Art

C. P. Townsley
Mission San Juan Capistrano,
1916
Oil on canvas
32 x 40 inches

Julie Morrow
Mission Garden,
San Juan Capistrano
Oil on canvas
26 x 30 inches
George Stern Fine Arts,
Los Angeles

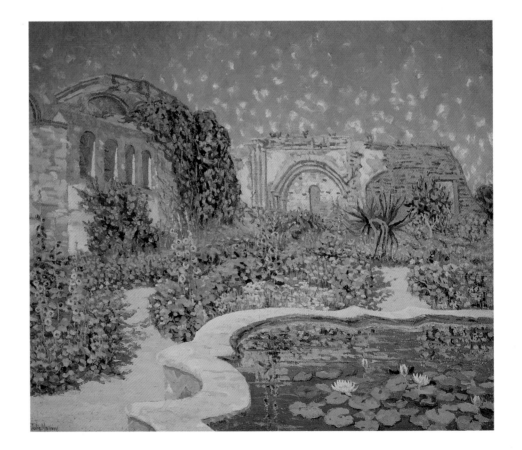

Like Realism, its immediate predecessor, Impressionism repudiated most of the tenets of the Academy. The time consuming, over-worked method of painting which required days or weeks to produce a painting was spurned by the Impressionists. They lamented the artificiality of light and color which often characterized an academic canvas, a consequence of painting in the studio. Impressionists preferred instead to paint directly on primed canvas and to set the easel out-of-doors.

Philosophically, Impressionists sought more relevance in subject matter, turning to everyday life for artistic motivation. They aspired for art that reflected the people as they were, and that necessitated acceptance of the urban setting and rejection of the false ideal of peasant life as simply another artistic convention not based on reality. Reluctant to pose a composition, Impressionists explored the "fleeting moment" or the "temporal fragment" in ordinary life. Where the Realists yearned for a contemporary view of history, the Impressionists sought an instantaneous view.

Impressionism made its debut in Paris in 1874. The new style of painting was greeted with much criticism and derision. In all, the small group of painters, including Claude Monet (1840-1926), Camille Pissarro (1830-1903), Pierre-Auguste Renoir (1841-1919), Edgar Degas (1832-1917), Alfred Sisley (1839-1899), Georges Seurat, and Paul Cezanne (1839-1906), among others, exhibited together only eight times. Strong disagreements over theory and practice led to the eventual break-up. Mary Cassatt (1844-1926), an American painter living in France, was accepted as a member of the group in 1879 and participated in later exhibitions. Theodore Robinson (1852-1896) lived a great part of his short life in France and was a friend of Claude Monet. Although he did not exhibit with the Impressionists, he nevertheless was one of the first American artists to return to the United States espousing Impressionism.

The first exhibition of French impressionist paintings in America was held in Boston in 1883. The display consisted of works by Monet, Pissarro and Sisley, among others. In 1893, the World's Columbian Exposition in Chicago had a significant art section devoted to American impressionist painters, and in 1898, "The Ten American Painters" was formed in New York. "The Ten" was a group of professional impressionist artists who organized for the purpose of exhibition and sale of their paintings. They were Frank W. Benson (1862-1951), Joseph De Camp (1858-1923), Thomas W. Dewing (1851-1938), Childe Hassam (1859-1935), Willard L. Metcalf (1853-1925), Robert Reid (1862-1929), E. E. Simmons (1852-1931), Edmund C. Tarbell (1862-1938), John H. Twachtman (1853-1902), J. Alden Weir (1852-1919) and William Merritt Chase (1849-1916), who was invited to join after the death of Twachtman.

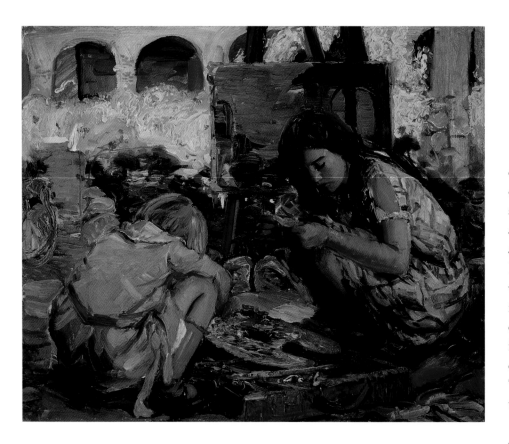

Joseph Kleitsch
Curiosity, 1914
Oil on canvas
25 x 30 inches
Collection of Mr. & Mrs.
Thomas B. Stiles II

Just as the original group of French Impressionists consisted of diverse personalities with disparate aims and philosophical approaches, American Impressionists likewise were practicing different forms of the style and, on occasion, straining the limits of what can be loosely defined as Impressionism. There was no theoretician to lead the movement.

Moreover, Impressionism came to America at least a decade after its riotous debut in France. As such, American painters benefited from the soothing effects of time on a critical art public. Also, they had the luxury of picking and choosing from among a number of techniques and approaches, many of which were developed by artists who had progressed beyond Impressionism. These methods concerned themselves with specific uses of subject, color and line, and related to painting techniques followed by post-impressionist artists such as Paul Gauguin (1848-1903) and Vincent van Gogh (1853-1890).

By 1900, Impressionism, or what may be more properly termed "Impressionistic Realism," was the style of choice among American painters. Stylistically, it was a modified and somewhat tempered variant of the prototype French movement. The significant contributions of French Impressionism to American art were in the use of color and the specialized brushwork. Americans, in general, did not dissolve forms, a common practice with Claude Monet and his followers. The penchant for realistic observation of scenes, long a staple of American painting, survived the Impressionist onslaught. The scientific theories of color as revealed by Chevreul were indeed well received by Americans, even by those who did not consider themselves Impressionists, and the outcome showed in paintings with brilliant and convincing effect of natural light. The loose, choppy brush stroke that characterizes an impressionist work was both the consequence of the quick manner of paint application and the desire to produce a brilliant surface covered with a multitude of small daubs of bright color.

The principal American teacher of Impressionism was William Merritt Chase. At first with the Art Students League in New York and later in his own art school in New York City and at Shinnecock, Long Island, Chase was insistent on imparting to his students the discipline and technique of painting "en plein air." To impress on them the necessity for quickness when painting outdoors, he admonished them, "Take as long as you need to finish the painting, take two hours if necessary."

The plein-air style continued to be popular in California until the end of the 1920s. By that time, many of the key figures that had made the style the vibrant and dynamic phenomenon of earlier years had died or ceased to paint. Moreover, the new generation of California artists who had admired, sought out and trained under the Impressionists had been lured into "new" styles based on tenets and concepts of European Modernism. Indeed, by the start of the Depression the direction of California art was set by an entirely new group of artists, and the California Impressionists were consigned to the past.

Jules Pages
Old San Fernando Mission
Oil on canvas
18 x 24 inches
Maureen Murphy Fine Arts,
Montecito, California

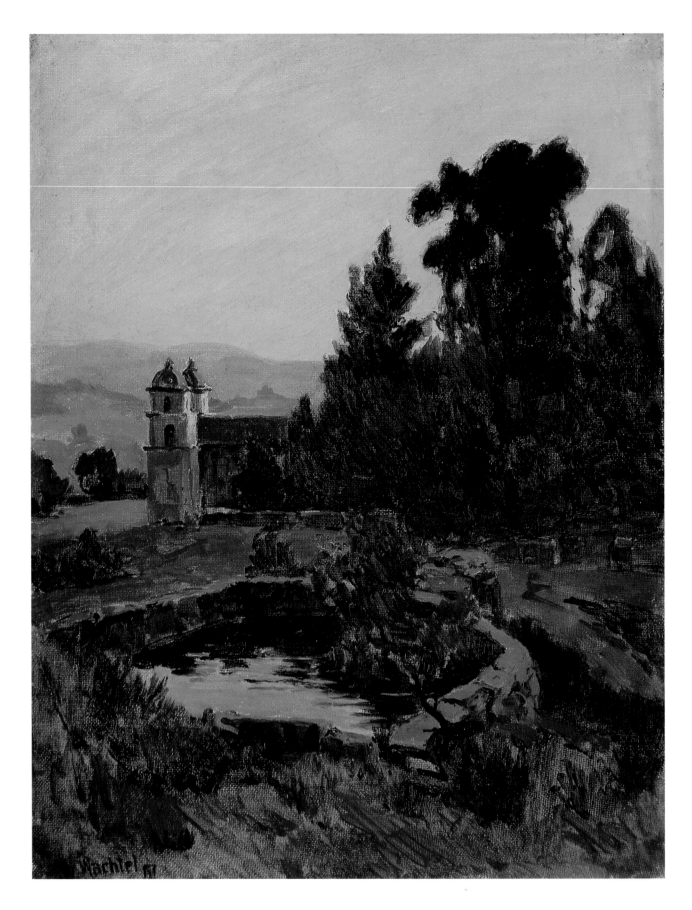

The California Missions in Art
1786 to 1890
by Norman Neuerburg

In response to a threat from the Russians, the Spanish Crown decided to initiate colonization of Upper California in 1769, more than two centuries after the land was first seen by Europeans in 1532. The main thrust of this colonization was carried out by Franciscan missionaries who founded twenty-one missions between 1769 and 1823 (four *presidios*, or forts, and three pueblos were founded by military and secular authorities during the same period) with the purposes of saving the souls of the native peoples by converting them to Christianity and of integrating them into a European-based civilization by teaching them trades that were not a part of native culture. The missions were vast and largely self-sufficient establishments centered around a church, but they also included workshops, storerooms, and residential buildings as well. Though only occasionally designed by an architect or master mason, the buildings were often of surprising magnificence. Adobe was the most common building material, but some of the more ambitious were of stone and brick, and roofs were usually of red tile. Until their secularization in the 1830s, they were the principal centers of agriculture, cattle raising and manufacturing in California. Once they were secularized, their lands and building were sold, though the land should have reverted to the Indians. Buildings that were not turned over to new functions gradually fell into ruin.

Because all the art at the missions had served a devotional or didactic purpose or was simple decoration, there was no motivation for the residents of the missions to record their surroundings graphically; but visitors found them objects of curiosity. The earliest known record of artistic rendering was at the time of the visit of the Frenchman Lapérouse in 1786. At San Carlos (Carmel) Mission, Gaspard Duché de Vancy (d. 1788) did a small painting, which he left at the mission, of Lapérouse's welcome there. The original has disappeared, but three copies of it were made by artists of the Malaspina expedition which came in 1791. They also drew sketches of the mission itself and of the *presidio* at Monterey. These—along with a drawing of an Indian dance at Mission San José by George Heinrich von Langsdorff (1774-1852), who had come with the expedition of Count Nikolai Rezanof, and a water color of an Indian dance in front of the mission church in San Francisco (Dolores) by Louis Choris (1795-1828), who came on the expedition of Otto von Kotzebue in 1815—are the only pictures related to missions before the end of Spanish rule.

After Mexican independence was achieved, California became more accessible to foreigners, and there was much trade in the 1820s and 1830s. Some of the ships carried draughtsmen or amateur artists. In 1826 and 1827 Richard Brydges Beechey (1808-1895) did sketches of the San Francisco and Monterey areas and of the missions there along with William Smyth (1800-1877). Not long after,

Opposite:
Elmer Wachtel
Secluded Mission, Santa Barbara
Oil on canvas
17½ x 13½

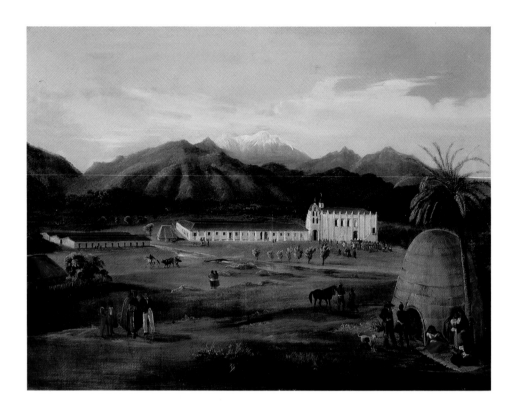

Ferdinand Deppe
San Gabriel Mission, c. 1850
Oil on canvas
27 x 37 inches
The Santa Barbara Mission
Archive Library

Auguste Bernard Duhaut-Cilly (1790-1849) drew a picture of Mission San Luis
Rey which subsequently was reproduced in the account of his voyage around the
world. In 1828 Alfred Robinson (1806-1895) visited California. Lithographs
based on lost drawings of his of four of the missions were published in his *Life in
California* in 1846. An amateur artist, Ferdinand Deppe, had been in California
in 1828 during one of six trips working for the merchant Virmond, and four years
later he did a painting of Mission San Gabriel while staying in Mexico City. This
is the earliest known oil painting of a California mission. In 1839 during a voyage
around the world, the French artist Francois Edmond Paris (1806-1893) did a
fine watercolor of Carmel Mission. In 1842 the Swede Emmanuel Sandelius, the
"King's Orphan," drew a number of very amateurish pictures of California,
including several missions.

The Mexican War and subsequent occupation of California brought a number
of soldiers and sailors to the region who stayed on. Some were artists of varying
ability. Sketches of the missions were relatively numerous in the late 1840s and
1850s. The no longer functioning missions were something unfamiliar to the east-
erners and began to take on the air of the romantic and the ancient. Disintegrating
missions fitted well into the prevailing nineteenth-century fascination with ruin,
and they had an appearance both exotic and antique. They certainly were exotic
by eastern standards, and even if they were not truly antique—the last mission
was founded less than a quarter of a century before the Bear Flag Revolt in 1846—
they at least looked old, and there was nothing like them along the eastern seaboard.
This romantic view of the ruined missions did not have its greatest impact until
the last decades of the century.

Among the men who came with the occupying forces were a few who had some artistic talent. They occasionally drew missions, such as the ship's surgeon Charles Guillou (1813-1899), William Rich Hutton (1826-1901), who left over a dozen sketches of missions, and the talented William Dougal (1822-1895). Alfred Sully (1820-1879), the son of the more famous Thomas Sully, drew in Santa Barbara and Monterey, married a local beauty who soon died, and remained in the army until his death. H.M.T. Powell had come over the Santa Fe Trail and settled in San Diego where he attempted to eke out his meager income by selling drawings. His oil of Mission San Diego is perhaps the second oil painting of a California mission. One of Powell's customers was Colonel Cave Couts (b.1821), who erased Powell's signature and fixed his own to two San Diego drawings. Couts, however, did have some talent as a draughtsman, and in his journal is a fine and quite objective drawing of the guards' quarters at Mission San Luis Rey in 1850. A drawing he did of the same mission is curious for its rather hallucinatory distortion, being exaggerated in its height, but it was well-enough regarded to be published as a lithograph.

During the 1850s a number of artists found an outlet for their talents as draughtsmen attached to expeditions sent to map the coastline and the borders between the United States and Mexico as well as to locate practical railroad routes. Many of their drawings, some originals surviving, were reproduced as lithographs in the expedition reports.

James Madison Alden (1834-1922), working on the Coast Survey from 1854 to 1857, executed numerous drawings and watercolors up and down the length of California. Among these are watercolors of three of the missions and the only known view of the chapel at the *presidio* of Santa Barbara.

Heinrich Baldwin Mollhausen (1825-1905), while working on the Pacific Railroad Survey, did a very fine view of Mission San Diego which was reproduced as a lithograph. In the same volume, the artist of an interesting view of Mission San Fernando from the hill behind is not documented.

Before 1856 artists merely depicted those missions which they chanced upon in their travels, but in that year the otherwise unknown Henry Miller set out to draw all the missions from San Francisco to San Diego and thus executed the earliest known set of mission pictures. Miller also drew a number of towns and cities, including San Luis Obispo, Santa Barbara, Los Angeles, San Bernardino and San Diego. These were intended to be used in the execution of a vast panorama

H. M. T. Powell
Mission San Juan Capistrano
Pencil drawing
Courtesy of Bancroft Library,
University of California,
Berkeley

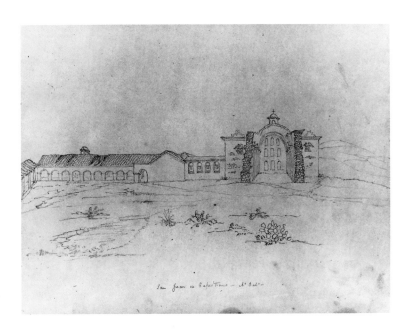

of California, but as far as we know it was never carried out. Miller had intended to finance his trip by selling drawings along the way, but he found no takers.

Léon Trousset's painting of Mission Santa Cruz of about 1853 may be the third oil painting of a California mission.

The 1860s were a rather dry period for representations of the missions. The sole major exception is the group of sketches by the Bavarian Edward Vischer, which he began in 1861, almost two decades after his first visit to California in 1842. The series, which includes multiple views, was completed only in 1878, the year of his death. Vischer was self-taught but added considerable life to his views, which often included the landscape setting. Photography of the missions had begun in the 1850s, but it only began in earnest in the 1870s, and Vischer occasionally based his sketches on photographs when little remained of the original appearances of the buildings. Perhaps the most influential photographer was Carleton Watkins, who did the first photographic series of the missions in the years 1876 to 1900.

The 1870s were a critical period for interest in the missions. During the research trip of Hubert Bancroft and Henry L. Oak in 1874, they encountered Lemuel Wiles (1828-1905) at work painting at San Juan Capistrano. He also did paintings of San Luis Rey and San Gabriel during a sojourn in San Diego that year. Edwin Deakin (1838-1923), an Englishman, settled in San Francisco in 1870 and did sketches and paintings of the mission there. His next mission pictures were done at San Buenaventura and Santa Inés in 1875, but he did not decide to do a whole set until 1878, and that was not finished until 1898. He actually did three sets, two in oil and one in watercolor. He also did a number of views not belonging to those sets. He was the first artist to romanticize the missions and the first of these artists with a very recognizable personal style, emphasizing paint texture and atmosphere, though many of the representations are less than accurate.

An artist more concerned with an accurate recording of the appearance of the missions was Henry Chapman Ford (1828-1894). Already successful as a landscape painter in Chicago, Ford came to California in 1875 for reasons of health and did his first mission sketch in San Francisco. He soon moved to Santa Barbara and exhibited two paintings of the Santa Barbara mission in his first exhibition that year. As the first professional artist in Santa Barbara, he began to supply paintings, both in oil and watercolor, to winter visitors, much as Guardi and Canaletto had done in eighteenth-century Venice for visitors on the Grand Tour. In 1878 he spent the summer in Yosemite and met Carleton Watkins, whose series of photographs of the missions may have inspired Ford to undertake a

complete series of paintings. In 1880 he went south and did numerous sketches, watercolors and oils of the missions south of Santa Barbara. The next year he went north. He kept almost all of these works to be used as models for replicas. In fact, he produced one set almost immediately for a client from Boston. Because of the good reception of these paintings, he decided to reproduce them in a more economical form for less wealthy visitors. At first he expected to have these reproduced in chromolithography, but instead prepared a portfolio of etchings. This included twenty of the missions (he had been unable to obtain any view of San Rafael, which had disappeared almost immediately after its secularization) plus the *asistencia* of San Antonio de Pala. Three of the missions were represented by two views, making a portfolio of twenty-four prints. These were the first etchings of the California missions. They were actually made by him in New York, but subsequent printings of these and other mission views of his were printed in California. He continued doing both paintings and etchings of the missions along with other subjects. He did a complete set including San Rafael (after he was able to get a drawing from General Vallejo) in watercolor which was shown at the World's Columbian Exposition in Chicago in 1893. That set was subsequently sold to Mrs. Stanford. Ford prepared a manuscript of a book on the missions which he intended to be illustrated with his own views, but he died before it was published. He was a very realistic renderer of the missions, and his etchings are perhaps the most widely reproduced of artists' renderings of the missions.

Henry Chapman Ford
Mission San Juan Capistrano, 1880
Oil on canvas
16 1/2 x 29 1/2 inches
Historic Mission Inn
Corporation, Riverside, CA

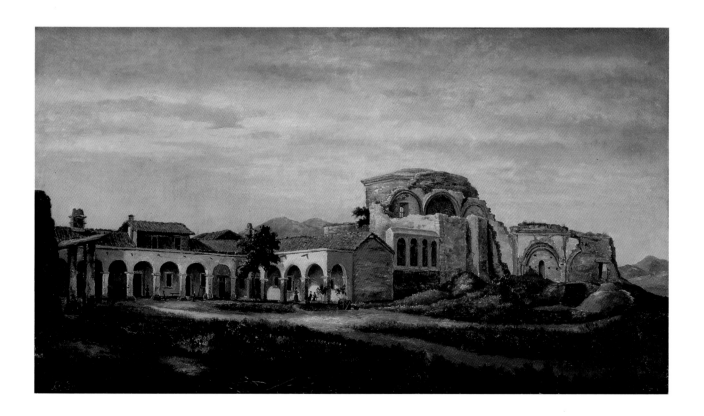

Henry Chapman Ford
Above: Purissima (sic) (Mission
La Purísima Concepción),
c. 1883
Below: Purissima (Old) (sic), *'83,*
1883
Etching
7 x 13 inches

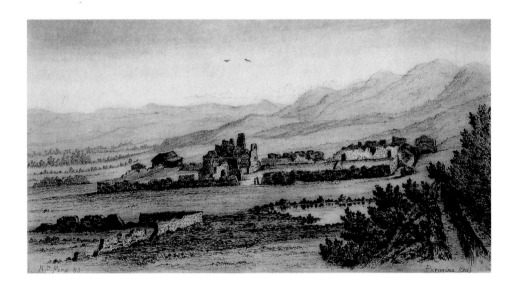

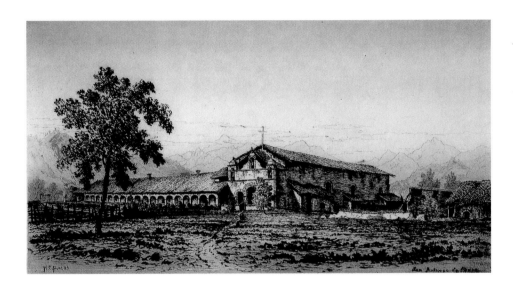

Henry Chapman Ford
Above: San Antonio de Padua, '83
(Mission San Antonio de
Padua), 1883
*Below: Pala, '83 (*San Antonio
de Pala), 1883
Etching
7 x 13 inches

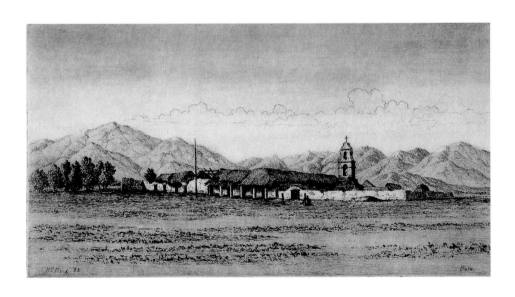

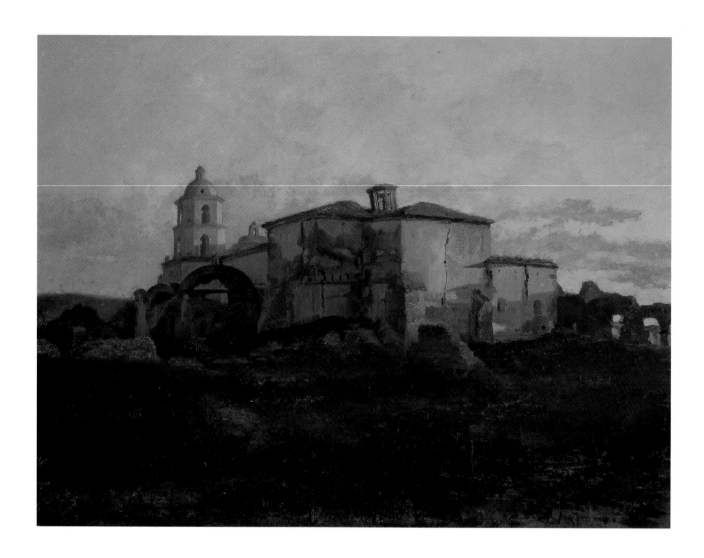

Alexander F. Harmer
San Luis Rey Mission, 1892
Oil on canvas
18 x 24 inches
Arlington Gallery,
Santa Barbara

Ford's place as the leading artist in Santa Barbara was taken by Alexander Harmer (1856-1925), who had married into an old California family and settled in that city in 1893, shortly before Ford's death. In the late 1880s, however, he had done a number of fine oils of both San Luis Rey and San Juan Capistrano missions. Having been a student of Thomas Eakins in Philadelphia, he was the first professionally trained artist to paint the California missions seriously. These works are straight-forward, accurate renderings of what he saw. After settling in Santa Barbara, he turned to portraying a very romantic view of early California of the sort which had become popular after the publication of Helen Hunt Jackson's novel *Ramona*.

The 1880s saw the appearance of a number of articles on the missions in national publications and the first books on the subject. As a result, a large number of artists did one or more mission paintings, though few attempted series. We find artists such as William Keith (1838-1911), Thomas Hill (1829-1908), J. Henry Sandham (1842-1912), and a host of other artists of lesser renown doing

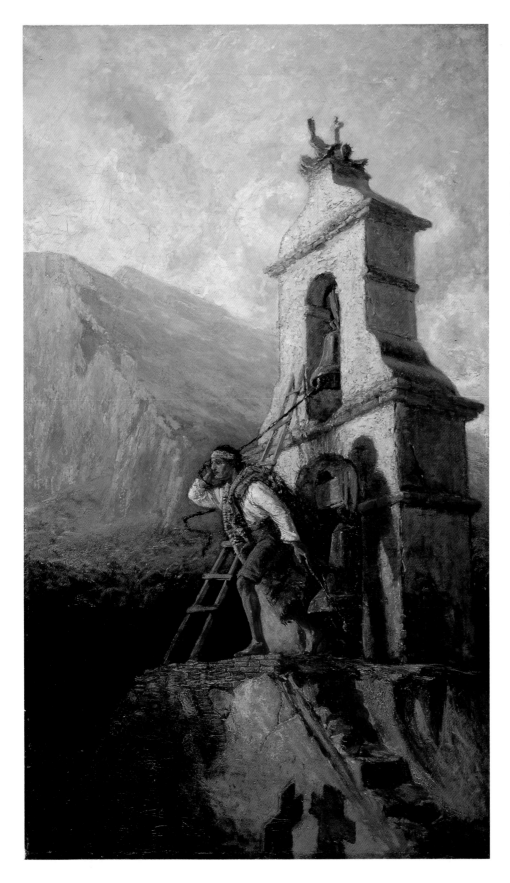

Henry Sandham
Toll for Sunrise Mass,
Pala Mission, 1889
Oil on canvas
48 x 28 inches
Dr. & Mrs. Edward H. Boseker

Charles Arthur Fries
Too Late, 1896
Oil on canvas
25 1/8 z 35 1/8
The Corcoran Gallery of Art,
Gift of Mrs. Alice Fries King,
in Memory of Her Father

occasional paintings of missions. Many of these, and others, prepared drawings to be reproduced as illustrations, especially before the reproduction of photographs became widespread. Numerous amateur painters, frequently women, painted missions, and they continued the tradition. Miss Jane Hunt, a niece of the brothers Richard and William Morris Hunt, the noted architect and painter, did a large number of watercolors of the missions during the years 1888 to 1894. Eva Scott Fenyes (1846-1930) also did a very large number of watercolors of the missions and old adobe houses between 1896 and 1926.

After the railroad came to San Juan Capistrano in 1887, painters arrived in large numbers to paint its mission. Over the years possibly no other mission had so many paintings done of it. Some artists even rented space as studios in the unruined parts of the mission buildings. In 1894 Judge Egan commissioned Fred Behre to paint a reconstruction of the San Juan Capistrano mission with a wildly improbable steeple over the entrance of its Great Stone Church. It was incorrectly believed to be the way the church looked before the 1812 earthquake. Excavations in 1938 showed that the steeple placement shown in the painting was impossible. The landscape in the background of this painting was modified by Gutzon Borglum (1861-1941). He began to frequent the mission along with his first wife Elizabeth Collins Borglum (1848-1922), who had actually been his teacher. Charles Arthur Fries (1854-1940) lived in the mission in the late 1890s. His famous painting *Too Late*, which adorned doctors' waiting rooms across the country, is set in the old dining room of the mission. By that time the mission had become a special and favorite subject for artists of the plein-air school, which came into its own in California in those years.

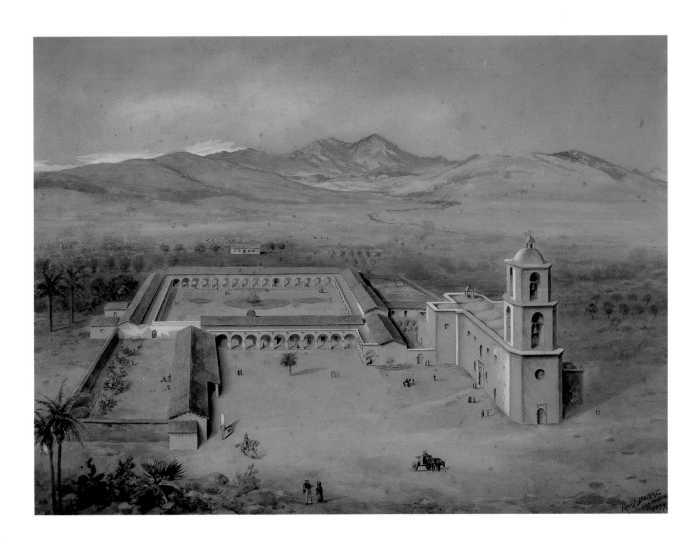

Fred Behre and
John Gutzon Borglum
Mission San Juan Capistrano,
1894
Watercolor and gouache
29³/₄ x 39¹/₂ inches
Mission San Juan Capistrano

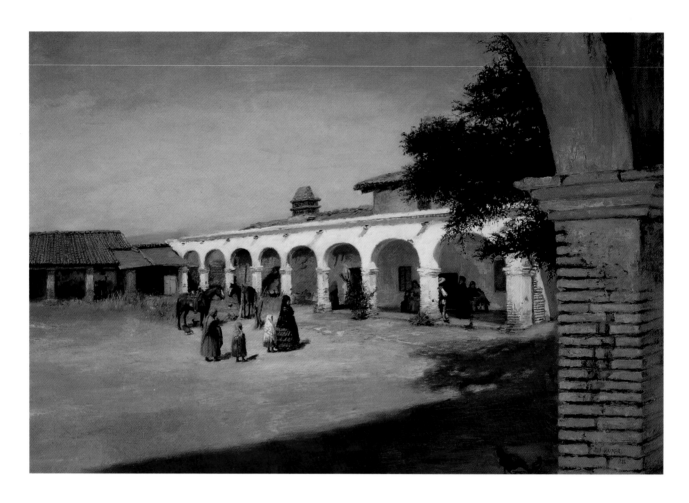

Alexander F. Harmer
Mission San Juan Capistrano,
1886
Oil on canvas
22 x 32 inches

The California Missions in Art: 1890 to 1930

by Jean Stern

With the growth of population of the early 1880s, Los Angeles began to attract professional artists. By the late 1880s several artists were already permanent residents. Within a decade there was an assorted group of young artists in Southern California who were trained in the impressionist style. Many had come south as they were unable find a niche in San Francisco, where the tastes and demands of the art establishment called for more traditional styles. Others were visitors who traveled here in search of picturesque and unusual subject matter and from time to time settled here. To these painters the romance and beauty of the old missions proved a strong attraction.

The small, seaside community of Santa Barbara was founded in 1786 when the Mission Santa Barbara was established near a large village of Chumash Indians. After secularization, the mission continued to function as a church without interruption for the benefit of the American population that had settled there.

Alexander F. Harmer (1856-1925) was Santa Barbara's most prominent artist. One of the most colorful of California's artists, Harmer had run away from home in Newark, New Jersey, at thirteen, made his way west to Nebraska, enlisted in the United States Army at sixteen and served duty in California.

He petitioned for release from the army so that he could enter art school at the Pennsylvania Academy of the Fine Arts in Philadelphia. There he studied with the two great American Realists, Thomas Eakins and Thomas P. Anschutz. His interest in the West compelled him to re-enlist in the United States Army, choosing the cavalry in hopes of being stationed in Indian Territory. As fortune would have it, he served in the Apache Wars in Arizona. The sketches of that campaign won him a position at *Harper's Weekly* as an illustrator.

By the early 1890s he was settled in Santa Barbara as a successful artist and lived there the rest of his life. He turned to portrait commissions and historical paintings of the Spanish California era, including many important works of the California missions.

Mission San Juan Capistrano, 1886 is one of the earliest fully developed professional paintings of the historic mission. The view is of the front courtyard looking across to the soldiers' barracks on the far left. The scene is populated by an assortment of people, some of them wearing day-to-day clothing and others in their finest attire. Two saddled cow ponies wait patiently in the hot sun while the Mexican cowboys talk to the padre. Remarkably, the grounds are utterly stark in appearance. There is no suggestion of gardens, grass or flowers, and only two stunted bushes adorn the otherwise barren pillars. Off to the right, we can see a few branches of the mission's distinctive California pepper tree.

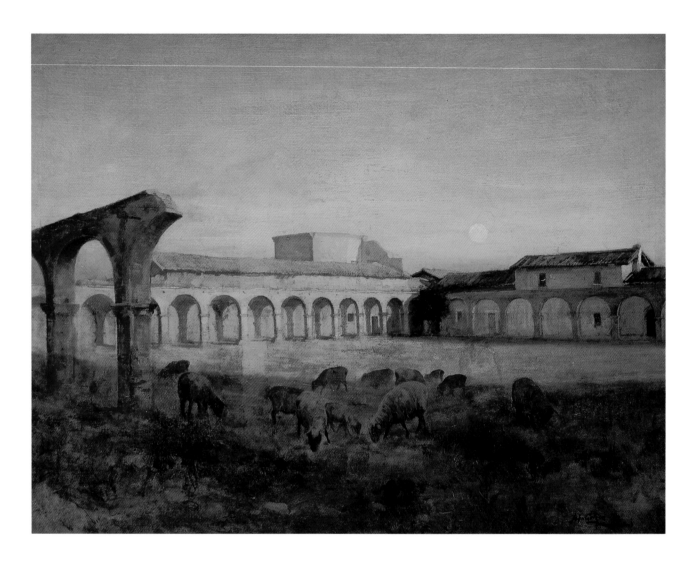

John Gutzon Borglum
Sheep Grazing,
Mission Capistrano, 1897
Oil on canvas
27 x 35 inches
Mission San Juan Capistrano

Harmer's rendition of *San Luis Mission,* 1892 (page 92) shows the large church nearly ruined. Large cracks cover the exterior walls, the results of California's frequent earthquakes. The chapel dome on the right is partially collapsed, and all around, exposed walls of adobe are slowly melting in the elements.

Los Angeles had three prominent artists in the 1880s. They were John Gutzon Borglum (1867-1941), his wife Elizabeth Putnam Borglum (1848-1922), and Elmer Wachtel (1864-1929).

John Gutzon Borglum trained in Los Angeles and San Francisco and painted large narrative works in the Barbizon style depicting California in the accepted Western conventions of the day. One such series of his paintings dealt with stage coaches. *Sheep Grazing, Mission Capistrano,* 1897 gives an engaging glimpse of the mission at a time when Southern California was an agrarian society. Borglum would later turn to sculpture and be best known for the monumental presidential portraits carved on Mount Rushmore.

His wife, Elizabeth Borglum, first came to Los Angeles in 1881. She was known as Elizabeth Jaynes Putnam or Mrs. J. W. Putnam before she married Borglum in 1889. She likewise worked in the tonalist-Barbizon esthetic. She had studied art in San Francisco, with William Keith in 1885 and J. Foxcraft Cole (1837-1892) in 1887, both of whom were well entrenched in the Tonalist-Barbizon style. Her *Mission San Juan Capistrano,* 1895 shows the arcades in late afternoon with gentle shadows falling on the pillars. In the years following secularization,

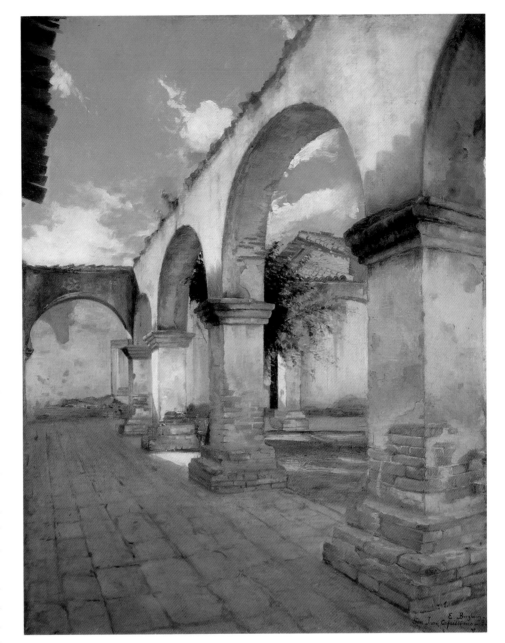

Elizabeth Borglum
Mission San Juan Capistrano,
1895
Oil on canvas
35 x 28 inches
Mission San Juan Capistrano

the Capistrano mission was plundered of its roofing tiles and timbers. It is note-worthy that by 1895, as the painting shows, the restorations had not yet included re-roofing the arcades.

The most influential early artist in Los Angeles was Elmer Wachtel, who came in 1882 and supported himself as a concert violinist as well as a painter. Even though he studied with the American impressionist master William Merritt Chase in New York, Wachtel's early works are markedly in the dark and moody tonalities of the Barbizon aesthetic, with glimpses here and there of an elegant line reminiscent of Art Nouveau.

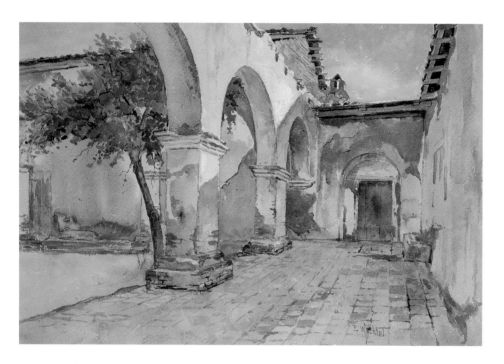

Elmer Wachtel
Mission San Juan Capistrano
Watercolor
11 1/2 x 17 inches

One of Elmer Wachtel's earliest views of the Capis-trano mission is a small but exquisite painting of the arches, done sometime in the mid-1890s before resto-ration of the roofs over the arcades and before the artist was influenced by Impressionism. Compare Wachtel's watercolor, *Mission San Juan Capistrano* with the large oil painting of the same title by Elizabeth Borglum, dated 1895. Wachtel's *Mission Santa Barbara at Sunset* (page 84) is also an early work, with its characteristically moody use of color in keeping with Wachtel's Barbizon affiliations.

Wachtel realized the romantic aspect of the Capistrano mission when he painted *Moonlight, San Juan Capistrano*. The drama of the composition is empha-sized by the ghostly presence of the mission as it materializes in the soft light of the moon. His large daylight representation of Capistrano, entitled *California Mis-sion* (page 49) gives the viewer a direct look into the ruins of the Great Stone Church that fell in the earthquake of 1812.

In time, and with the influence of Impressionism, Wachtel lightened his palette and used brighter color harmonies. *Capistrano Mission* is, by contrast, full of light and color and exhibits a tremendous sense of depth and atmosphere. This is the view of Mission Capistrano that would greet visitors as they first approached the buildings. The most prominent features are the old *campanario*, or bell wall, and the semicircular "mission revival" gable, an architectural feature that has come to symbolize the mission but in fact was not part of the original design. In addi-tion, this perspective includes the majestic California pepper tree near the corner of the arcade. It is thought that this tree was planted in the 1870s, and one can

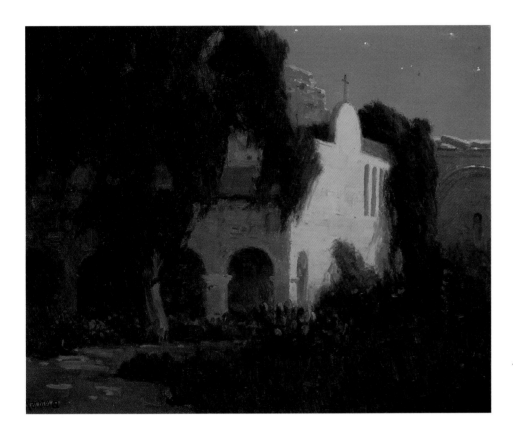

Elmer Wachtel
*Moonlight, Mission San Juan
Capistrano*
Oil on canvas
16 x 20 inches

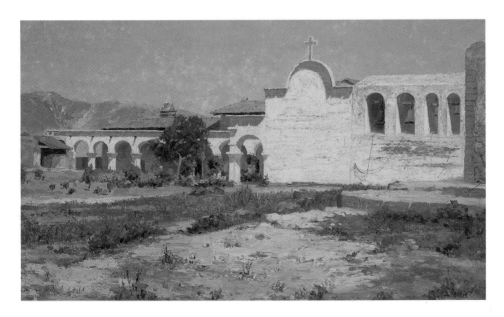

Elmer Wachtel
Capistrano Mission
Oil on canvas
15 x 25½ inches
The Fleischer Museum,
Scottsdale, Arizona

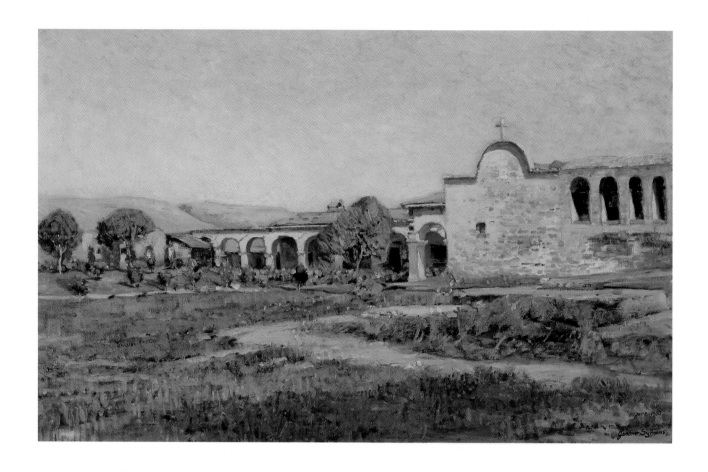

Above:
George Gardner Symons
San Juan Capistrano Mission,
June 1900
Oil on canvas
19 x 30 inches
Dr. & Mrs. Edward H. Boseker

Right:
Benjamin Brown
Sunrise, Mission at Pala near San Luis Rey, c. 1898
Oil on canvas
16 x 20 inches
De Ru's Fine Arts,
Bellflower, California

get a good idea of the date of Capistrano mission paintings by the relative size of the tree. Here, the tree appears to crest five or six feet above the arcade.

A remarkably similar view of the Capistrano mission was painted by George Gardner Symons (1862-1930), a Southern California visitor at the time who would later settle in Laguna Beach. *San Juan Capistrano Mission* is painted from what must surely be the same vantage point (and possibly the same day) as that used by Wachtel, leading to the intriguing prospect that these artists were working side by side.

Benjamin C. Brown (1865-1942) visited California as early as 1885 and settled in Pasadena in 1896, where he taught painting to supplement his income as an artist. His style is boldly impressionistic, with a profusion of bold colors applied in strong, definite strokes. *Sunrise, Mission at Pala near San Luis Rey*, painted about 1898, shows Brown's brilliant use of masses of small daubs of color. Brown captured the crisp, cold light of early morning as it creeps down the mountainsides towards the newly awakened community of Pala. A related painting, *The Mission*, shows Mission San Luis Rey from a distance. As with many of the

Benjamin Brown
The Mission
(Mission San Luis Rey)
Oil on canvas
18 x 24 inches

California plein-air artists, the landscape is often the subject of the painting, with the historic mission as an integral part of the larger picture.

Early in his career, Brown exhibited in a New York art gallery and was meeting considerable success. The art dealer suggested that they could boost sales by concealing that Brown was a Californian. Brown protested loudly, and from that point he always put "California" boldly below his signature on the finished painting.

Guy Rose
San Gabriel Mission
Oil on canvas
28³/₄ x 23³/₄ inches
The Fleischer Museum,
Scottsdale, Arizona

The most gifted of California's impressionist artists, Guy Rose (1867-1925) was the only artist of the early period to be born in Southern California. His father, L. J. Rose, owned the Sunny Slope Ranch, located in the San Gabriel Valley about ten miles east of Los Angeles. The Mission San Gabriel Arcángel was a familiar landmark to Rose, who grew up within the "sound of its bells."

Rose studied at the California School of Design in San Francisco in 1886 and 1887 before continuing his studies in Paris. In France, Rose adapted well to Impressionism and, like scores of other art students and young painters, visited Giverny, the small village where Claude Monet lived. He returned to Giverny in 1904 and lived there with his wife Ethel, also an artist, until 1912 when they returned to the United States. Sources vary as to the extent of the friendship between Rose and Monet, whose influence is clearly evident in Rose's work.

Back in America, Rose worked in New York and returned to Los Angeles in 1914, settling in Pasadena. The seven year period between 1914 and 1921,

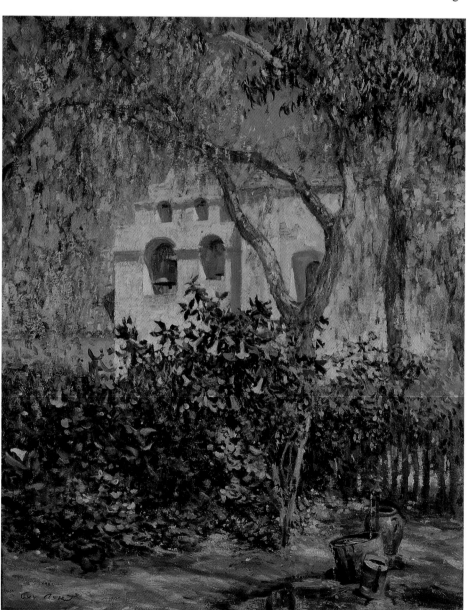

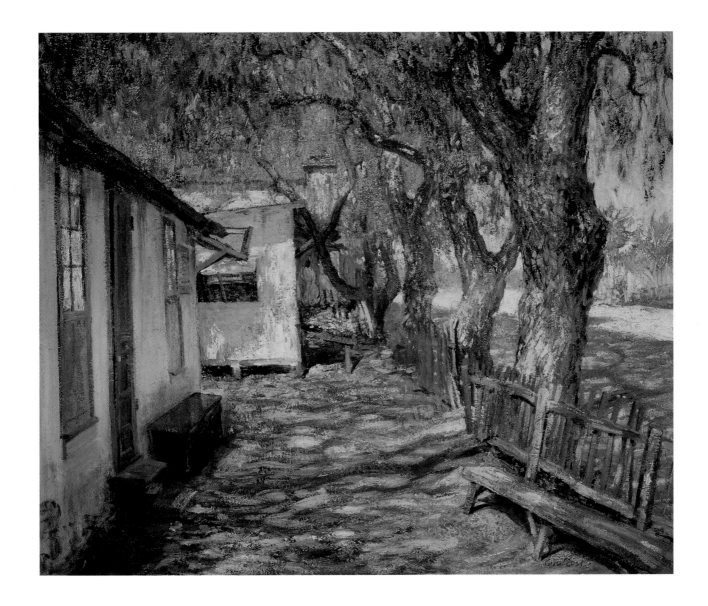

when he was disabled by a stroke, confines his California works. In that brief time, Rose painted in La Jolla, Laguna Beach, San Gabriel, Pasadena, the Carmel-Monterey area, the Sierra Nevada Mountains and the Mojave Desert.

San Gabriel Mission and *San Gabriel Road*, both painted about 1919, are the only known paintings that Rose painted of any California mission. In both cases the mission takes a secondary role as a framework for an interesting little out-door still-life of pots in the mission yard, or as a barely discernible backdrop for the view of houses and trees along San Gabriel Road. Curiously, no paintings of the Mission San Juan Capistrano are known to have been painted by Rose. *The Leading Lady* (page 14) is set within the ancient arcades of San Gabriel mission. It is a portrait of Lucretia del Valle, a well-known actress of the day, in the role of Señora Josefa Yorba, a character in *The Mission Play*. This pageant, written by John Steven McGroarty in 1912, was held annually at the San Gabriel mission.

Guy Rose
San Gabriel Road
Oil on canvas
24 x 29 inches

Rose was the most impressionistic of all artists in California, pursuing a delicate and elegant brush stroke coupled to soft, harmonious colors. He was the only one of our artists who had a direct association with the French Impressionists, and his work is highly evocative of Monet's. In 1894 Rose suffered a debilitating bout of lead poisoning, the result of constant exposure to oil paints. For several years, he rarely worked in oils, turning instead to pen and ink or watercolor illustration work for major periodicals. By 1904, his first year of residency in Giverny, he had sufficiently recovered to paint on a frequent basis. He did not paint from 1921, the year of his stroke, until his death in 1925.

Franz A. Bischoff (1864-1929) was a fully trained European artist when he came to America in 1885. His specialty was porcelain painting, and he excelled at the rendition of flowers, particularly roses. Prior to coming to California, he lived in Dearborn, Michigan, where he taught porcelain decoration and watercolor painting. In 1905 he visited San Francisco with the aim of moving his family. The earthquake of 1906 forced him to reconsider his choice, and instead he built a home and studio in South Pasadena. Thus, he began a second career as a landscape painter.

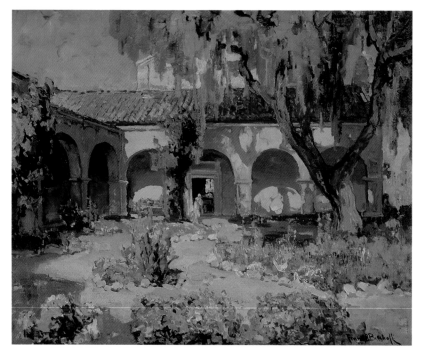

Franz A. Bischoff
Capistrano Mission
Oil on canvas
24 x 30 inches
Paul & Kathleen Bagley

San Juan Capistrano Mission Yard (page 1) was painted about 1922. It shows the fountain at the entry of the mission with the "mission revival" gable and the *campanario* in the background. The fountain bears a statue of an angel in the center, a feature which has been changed several times over the years. Always a flower painter, Bischoff focuses on the hollyhocks and geraniums around the fountain and creates a vivid and brilliant statement of California's light.

One of the greatest colorists in California art, Bischoff's work glows with light and color. *Capistrano Mission* treats what would otherwise be a commonplace scene of the courtyard and pepper tree into a glorious statement of brilliant light and color.

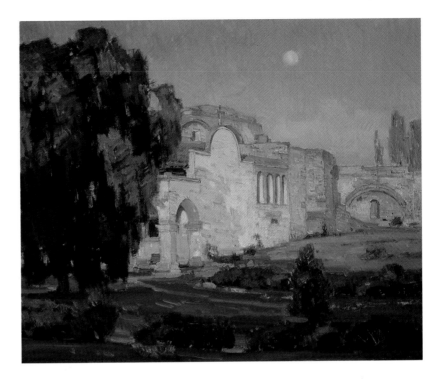

German-born William Wendt (1865-1946) came to the United States in 1880 and settled in Chicago. Largely self-taught, he immediately took to landscape painting, winning many prizes in numerous exhibitions in Chicago.

During the late 1890s, Wendt visited California on several occasions. He was enchanted by the landscape, and in 1906 he and his wife, the sculptor Julia Bracken Wendt, bought a studio-home in Los Angeles. A few years later they relocated to Laguna Beach where they lived the rest of their lives.

Wendt was a frequent visitor to the Mission San Juan Capistrano. He painted the mission on many occasions, including one work (page 66) that he presented to the resident padre with the special dedication just above his signature beginning, "To my friend Father O'Sullivan…"

Wendt is often described as the most spiritual of California's landscape painters. His works are intimate and personal views of the land and the environment. Many of his

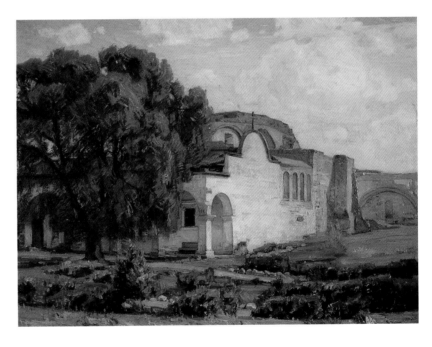

works bear poetic titles, some drawn from the Bible or other works of classical literature. His nostalgic view of Capistrano in moonlight is entitled *Of Bygone Days*. Keeping with the nostalgia and romance of Old California, another Capistrano painting bears the title *An Echo of the Past*. The human presence is rarely seen in his paintings, and at times that presence is shown to the detriment of the land. A well-respected artist among his peers, he was called the "dean" of Southern California's landscape painters.

William Wendt
Above: Of Bygone Days
Oil on canvas, 25 x 30 inches
The San Diego Museum of Art, Bequest of Mrs. Henry A. Everett
Below: An Echo of the Past, 1917
Oil on canvas, 30 x 40 inches
The Redfern Gallery, Laguna Beach, California

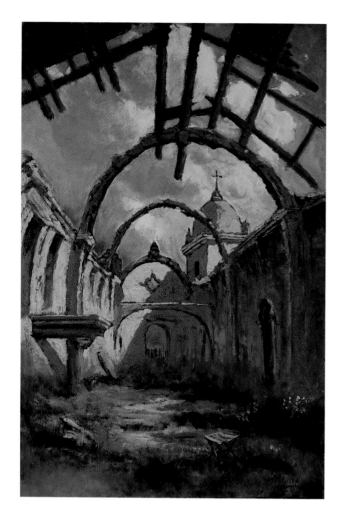

Manuel Valencia
Inside the Ruins of Carmel Mission
Oil on canvas
30 x 20 inches
De Ru's Fine Arts,
Bellflower, California

Manuel Valencia (1856-1935) was a Northern California artist who specialized in landscapes and historical themes. He was a descendant of a member of the De Anza Expedition, which surveyed various parts of California in the late 1700s. In recompense for that service, the Valencia family held numerous land grants in the San Francisco Bay area and had a street named in its honor in San Francisco.

Largely self-taught, Valencia studied briefly with Jules Tavernier (1844-1889), a painter of missions in his own right, and attended a few classes in Mexico City. The great San Francisco earthquake of April 1906 caused Valencia to move out of the city and relocate south of San Francisco in San Jose.

Inside the Ruins of Carmel Mission shows the damage from neglect and abandonment in the decades following the Mexican secularization decrees of 1833. *The Cemetery, Mission San Luis Rey* (page 17) likewise shows the partially collapsed dome of a chapel next to the church.

Alson S. Clark (1876-1949) was born in Chicago and studied in New York under William Merritt Chase. In 1900 he went to Paris where he took lessons with James A. Whistler. From 1902 to 1914, Clark and his wife Medora spent most of their time between their home in Chicago and an apartment in Paris. Clark was a tireless traveler, painting in such diverse locales as France, Italy, Spain, England, Dalmatia, Czechoslovakia, Canada, Panama and Mexico.

Clark served as an aerial photographer in the United States Navy during World War I. After the war he was advised to seek a warm climate to recuperate from a nagging ear affliction. He and Medora came to California in 1919, fell in love with the locale and bought a lot in Pasadena. When they returned with all their possessions on January 1, 1920, they hailed a taxi at Union Station and asked to be driven to Pasadena. The cab driver looked at them in astonishment and said it was impossible due to the Rose Parade. Nevertheless, five hours later they arrived at their new home.

Clark's first paintings after his return from service in World War I in 1919 were two small oil sketches of the San Gabriel mission. *Mission San Gabriel* is one of those. Clark was fascinated by architecture, and everywhere he went he painted examples of local architecture, from grand palaces to ordinary houses and streets.

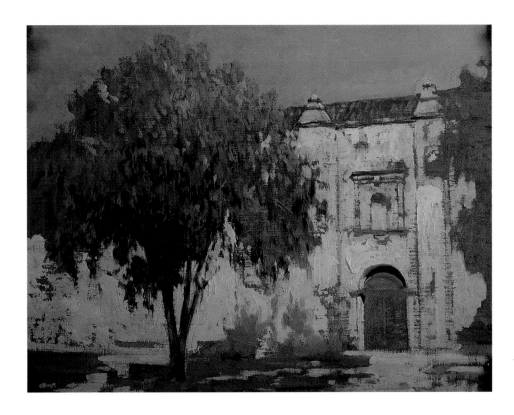

Alson S. Clark
Mission San Gabriel
Oil on canvas
12 x 16 inches

Alson S. Clark
Moonlight, San Juan Capistrano
Oil on board
15 x 18 inches

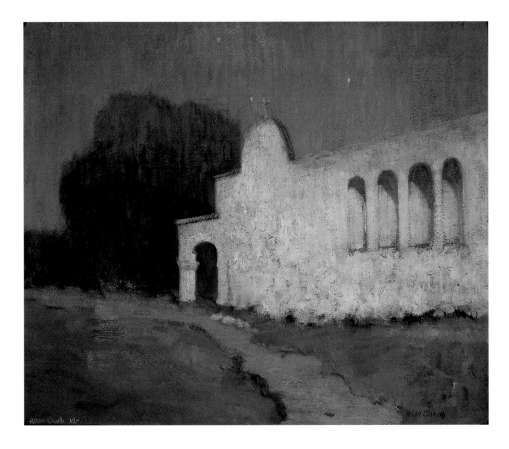

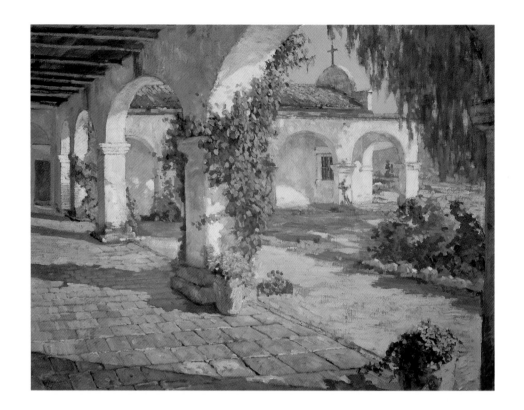

Alson S. Clark
Mission Cloisters, San Juan Capistrano, 1921
Oil on canvas
36 x 46 inches

Donna Schuster
Lily Pond, Capistrano Mission
Oil on canvas
24 x 30 inches
Collection of
Ranney & Priscilla Draper

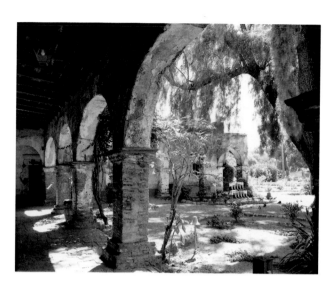

Not long after he and his wife settled in Pasadena, they made their first of many visits to the Capistrano mission. The old mission instantly became a subject of interest for Clark. *Mission Cloisters, San Juan Capistrano* is rendered with great affection. The golden light of late afternoon reflects in soft and gentle tones off the arcades and whitewashed walls of the old building. *Ruins of San Juan Capistrano* (page 11) focuses on the texture of the ancient walls. In *Moonlight, San Juan Capistrano* (page 109), Clark explores the ethereal setting by posing the mission in moonlight, giving it a stark, almost abstract simplicity.

Mission San Juan Capistrano, 1995. Photo by Casey Brown.

Donna Schuster (1883-1953) was trained in Chicago at the Art Institute and at the Boston Museum School under Edmund Tarbell and Frank Benson. Her early works clearly show the soft, delicate brushwork of the Boston School. Her later studies with William Merritt Chase in 1912 influenced her toward a broader, more painterly brush stroke.

Schuster arrived in Los Angeles in 1914 and became an active member of the local art community, exhibiting widely and frequently and teaching at Otis Art Institute. An astute and daring painter, she shows in her work a broad range, from the elegant Impressionism of the Boston School, to some paintings with exceptionally bright and bold color harmonies, and even to starkly Modernist compositions. Schuster does not lend herself to simple classification. She experimented with a multitude of art styles, seeking inspiration at various times from Chase, Claude Monet, and from the California Modernist, Stanton MacDonald-Wright (1890-1973).

Lily Pond owes much to the influence of Claude Monet, particularly in the selection of water lilies as subject. However, the pond is in fact the fountain at the Mission San Juan Capistrano. The composition of this painting eliminates all references to the background, but the silhouette of the mission is clearly seen reflected in the water.

Hungarian born Joseph Kleitsch (1882-1931) came to America in 1901 and established himself as a portrait painter. In 1912 he was commissioned to paint portraits of Mexican President Francisco Madero and his wife. On a visit to California in 1914, he stopped at the Mission San Juan Capistrano and painted *Curiosity* (page 82). A dedicated plein-air painter, Kleitsch was taking a break from the easel when two young girls came to see what the artist was doing.

Kleitsch returned to Southern California and settled in Laguna Beach in 1920. He took an active interest in the Mission San Juan Capistrano, producing a

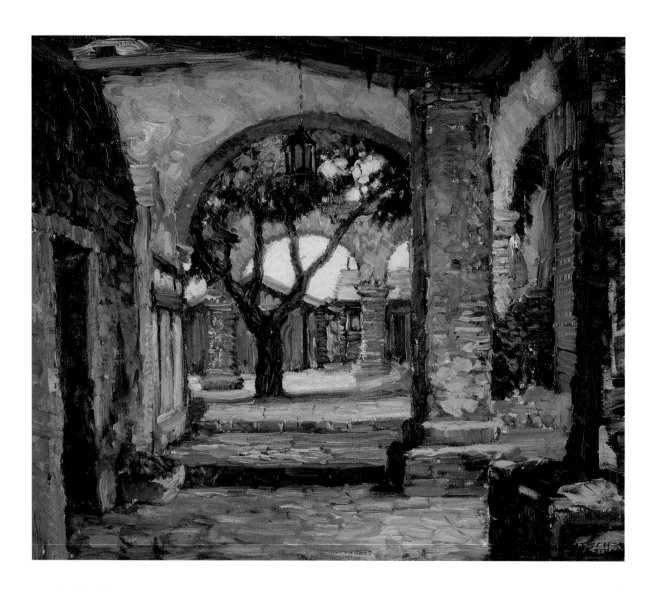

Joseph Kleitsch
The Cloisters,
San Juan Capistrano
Oil on canvas
17 x 20 inches

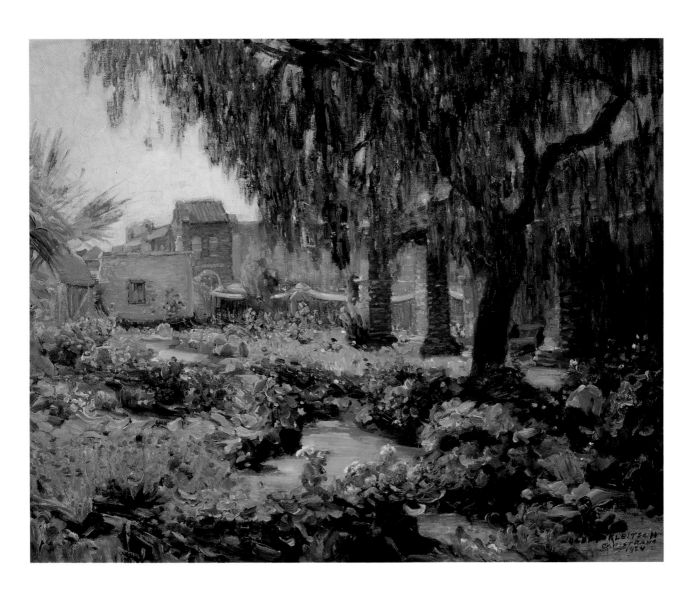

Joseph Kleitsch
San Juan Capistrano, 1924
Oil on canvas
24 x 30 inches

number of canvases in the early 1920s. *The Cloisters* (page 112) is an extraordinary painting of receding space and symmetrical forms. The scene down the corridor is framed by a series of arcs and perspective lines, creating an immense space that continually expands towards the viewer.

In 1924 Kleitsch painted *Portrait of Father John O'Sullivan* (page 64), the resident priest at the Capistrano mission. The work shows a pensive and resolute man set against a background of his beloved mission. Father O'Sullivan was instrumental in bringing the plight of the Capistrano mission to the public and is widely credited as "the man who saved the mission."

That same year, Kleitsch painted a superb view of the Capistrano mission gardens, looking towards the old town of San Juan Capistrano. *San Juan Capistrano*, 1924 (page 113) is one of the finest impressionist paintings produced in California. The surface is alive with a myriad of colorful daubs, giving the painting a feeling of immediacy and a brilliant sense of natural light. The composition does not center on the main buildings but rather turns away from them, showing only a glimpse of the soldiers' barracks on the right. The subject is indeed the light of California in all its brilliance.

Charles Percy Austin (1883-1948) was an artist who came to be associated with paintings of the Mission San Juan Capistrano. From about 1912, Austin began a long series of paintings of the Mission San Juan Capistrano that he exhibited frequently. He befriended Father John O'Sullivan and lived at the mission for extended periods while he painted. In 1930, he illustrated the book *Capistrano Nights* by Saunders and O'Sullivan.

The Capistrano mission owns several works by Austin, including *San Juan Capistrano* 1924, *Padre Reading* (page 67), and *Mary Pickford's Wedding*, 1924 (page 62). These were given to the mission by the artist. Austin's large painting, *San Juan Capistrano*, shows a padre feeding a parrot in the mission courtyard. The scene is encircled by the lush vegetation that typifies the popular image of California: a romantic and appealing land of flowers and light.

Charles Percy Austin
San Juan Capistrano, 1924
Oil on canvas
30 x 36 inches
Mission San Juan Capistrano

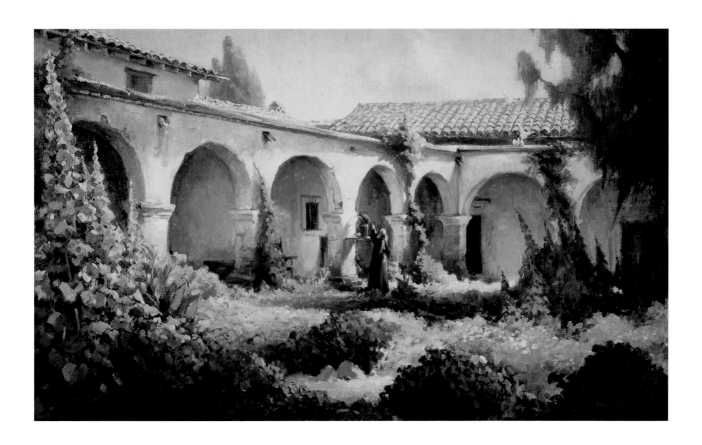

Charles Percy Austin
San Juan Capistrano, 1924
Oil on canvas
30 x 60 inches

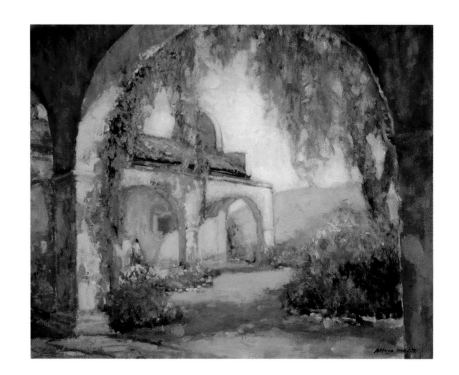

Arthur Hill Gilbert
Mission San Juan Capistrano
Oil on canvas
20 x 24 inches

Arthur Hill Gilbert
Santa Barbara Mission, 1924
Oil on canvas
30 x 24 inches
Collection of Terry & Paula
Trotter

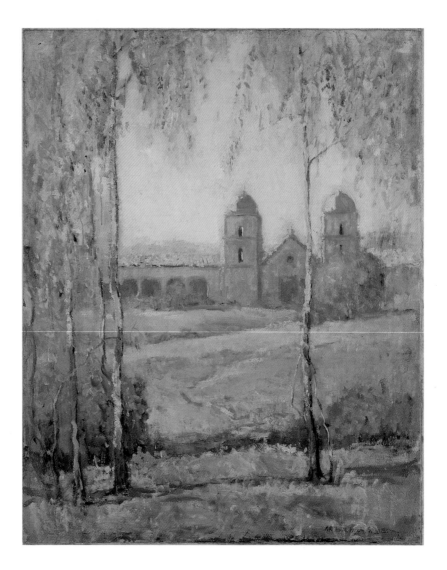

116

Arthur Hill Gilbert (1894-1970) was educated at Northwestern University and at the United States Naval Academy in Annapolis. In 1920, after his military service, he came to California and began his art studies. He enrolled at the Otis Art Institute and continued his training by taking classes in Paris and London.

In 1928 Gilbert moved to Monterey and became well known for his paintings of the picturesque trees, dunes and rugged coastline. In 1929 his painting *Monterey Oaks* won the coveted Hallgarten Prize at the National Academy of Design in New York. In 1930 he won two more significant awards, the Murphy and Ranger Prizes, and was elected an associate member of the National Academy.

While living in Southern California, Gilbert painted several works of the missions. *Mission San Juan Capistrano* is set beneath one of the arches looking across the courtyard to the "mission revival" gable. The mission and its romance are the subject of the painting, and the warm, peaceful sense of the California day, accented by the hanging bougainvillea vines, provides the setting for the mission. By contrast, *Santa Barbara Mission* is more a languorous California landscape than a painting of the mission. In his role as a plein-air painter, Gilbert treats the mission in the middle distance as an aspect of the landscape.

Philadelphian Colin Campbell Cooper (1856-1937) made his first visit to California in 1915 on the occasion of the Panama-Pacific International Exposition in San Francisco. That winter he came to Los Angeles and spent the first part of 1916 painting in Southern California, including San Juan Capistrano and San Diego.

Cooper was fascinated with architecture. His world-wide travels took him to many exotic lands, and everywhere he painted scenes of buildings, streets, and local architectural monuments. Upon his return to the United States, he painted a number of impressionistic city scenes of New York, a series that brought him significant acclaim. His interest in the Mission San Juan Capistrano is therefore understandable: the missions are the archetypic architectural landmarks of California, and Capistrano has long been called the "Jewel of the Missions."

Colin Campbell Cooper
Mission San Juan Capistrano
Gouache on paper
5 x 7 inches

Always a plein-air Impressionist, Cooper's work is bathed in brilliant color and light. A small gouache of the fountain and *campanario* entitled *Mission San Juan Capistrano*, dated June 24, 1926, is a marvelous sketch, accomplished with only a few, well-chosen strokes. Two other paintings

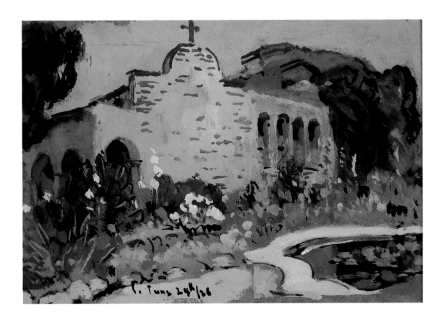

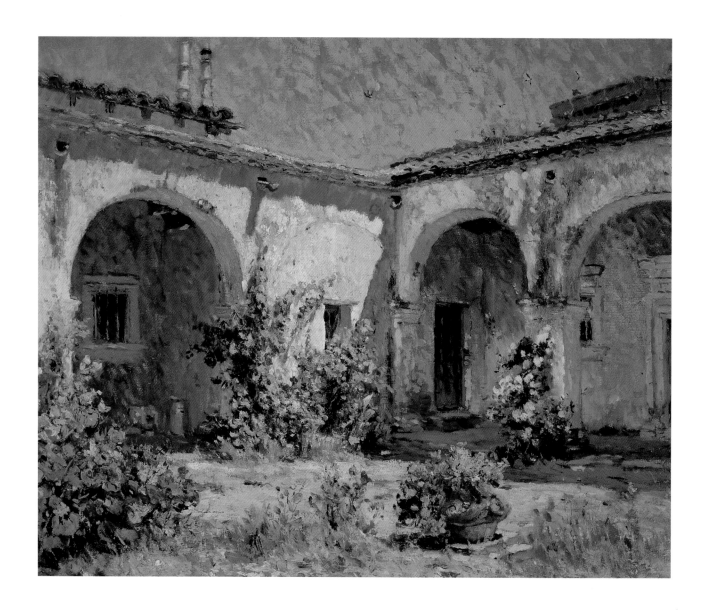

Colin Campbell Cooper
Mission Courtyard
Oil on canvas
17³/₄ x 21¹/₂ inches

of Capistrano, *Mission Courtyard* and *Mission San Juan Capistrano,* 1916 are painted from the identical viewpoint. The smaller work in gouache shows the immediacy of the watercolor technique. The painting includes the padre and an altar boy in a doorway, as well as chickens in the yard and pigeons in the air; it is indeed a "passing moment" caught by the painter. The larger work in oil has a lot more developed color and form with a strong and intense feel of natural light, but little of the agility that the sketch has.

Many of Cooper's Capistrano paintings are not of the mission. *Capistrano Train Station* (page 61) shows the Santa Fe train station that adjoins the mission. In the background, one can see a series of arches from the western edge of the mission. A large, busy highway now separates the station from the mission. *Near San Juan Capistrano,* dated May 7, 1916, is a view of Ortega Highway, the present-day thoroughfare that leads from the San Diego Freeway to the mission.

118

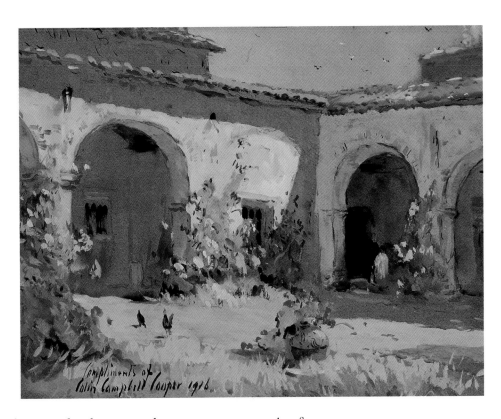

The sketch looks west from the mission to where the freeway now runs. Ortega Highway is named after Sergeant Ortega, the chief scout of the Portolá Expedition that explored the area in 1769.

Sydney Laurence (1865-1940) is best known as the foremost plein-air painter of Alaska. He arrived in Juneau in 1903 and moved to Valdez in 1904. He supported himself as a photographer but spent the summers prospecting for gold. Failing to strike it rich, he turned to painting and became an important chronicler of the Alaskan frontier. He is renowned for his views of Mount McKinley.

In 1925 Laurence began to spend winters in Los Angeles. He was then sixty years old and could not tolerate the long winters in Alaska. Although he continued to paint Alaskan scenes in his California studio, he occasionally painted plein-air scenes of the Southland. *The Evening Star* (page 68), a moonlight painting or "nocturne," shows the planet Venus at night hovering above the faintly lit ruins of the Capistrano arches.

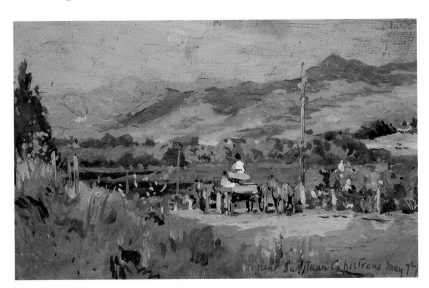

Colin Campbell Cooper
Above:
Mission San Juan Capistrano,
1916
Gouache on paper
10 x 12 inches
Mission San Juan Capistrano
Below:
Near San Juan Capistrano
Mixed media
5 x 7 inches

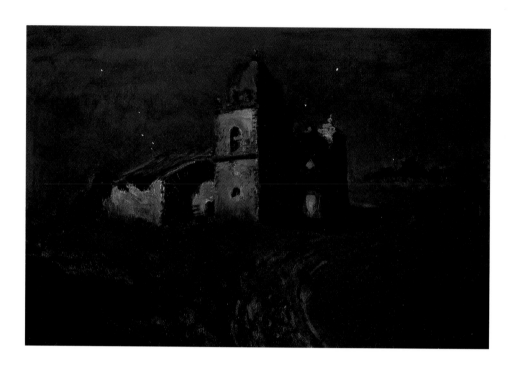

Charles Rollo Peters
Starlit Mission, Carmel
Oil on canvas
16 x 24 inches

Nocturne painting was the specialty of Charles Rollo Peters (1862-1928). Peters was a faithful follower of James A. Whistler (1834-1903), the American expatriate painter who popularized nocturne painting. *Starlit Mission, Carmel* shows the Carmel Mission in the eerie glow of clear moonlight. The dark setting intensifies the dramatic quality of the mission, a ghostly presence in an otherwise stark clearing.

Arthur G. Rider (1886-1976) was a Chicago area artist who studied at the Art Institute of Chicago. In 1910, he attended at lecture by the Spanish Impressionist, artist Joaquin Sorolla (1863-1923), and was an immediate convert to Sorolla's color esthetic. He spent several summers in Spain painting the fishing boats on the beach at Valencia. He painted in California in 1928 and, in 1931, he settled in Los Angeles. In Southern California, Rider found once more the intense light of the Spanish coast. He worked as a scenic artist for Twentieth Century Fox and MGM studios, retiring at the age of eighty-four.

Arguably the best colorist of all the California artists, Rider was charmed by the Capistrano mission, and his paintings of it are lively examples of Impressionism in California. Two paintings of the garden and fountain are delightful examples of Rider's vivid color use. These paintings capture the shimmer of

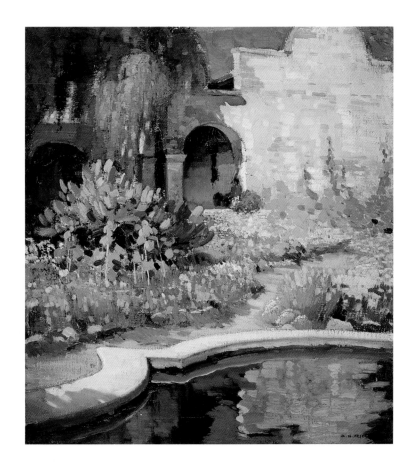

Arthur G. Rider
Mission Garden,
San Juan Capistrano
Oil on canvas
22 x 20 inches

Arthur G. Rider
Flowers, Capistrano Mission
Oil on canvas
28 x 24 inches
Paul & Kathleen Bagley

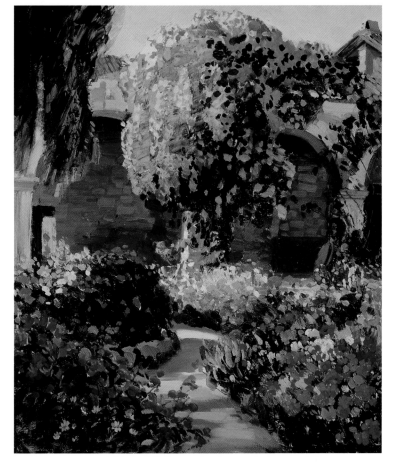

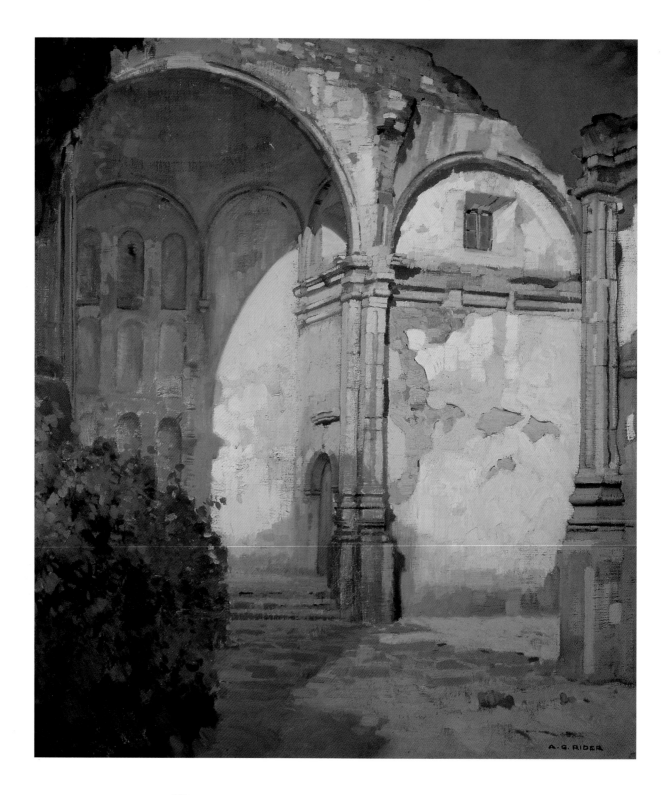

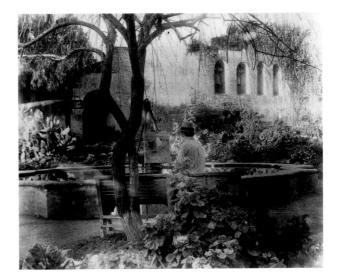

sunlight as it reflects off water, stone and brilliant flowers. The play of light among the mission's myriad of blooms is the subject of *Flowers, Capistrano Mission* (page 121). Rider leads us, with endless little daubs of pure color, along a geranium-bordered path to the wisteria vine that cascades from a pillar. *Capistrano Ruins*, by contrast, uses subdued color to set a tableau that emphasizes the heroic quality of the ruined church. Even though the painting lures the viewer with a series of overlapping arcs and lines, it is still the superb color that creates the dramatic impact.

California Impressionism, or the plein-air style, entered its decline with the advent of the Great Depression. The changing tastes of the art public, coupled to the uncertainties of the economic climate, led to the conclusion of this art style. Younger artists, many of whom were trained in this style, turned instead to European Modernism as their style of choice. In addition, artistic tastes favored paintings of urban settings and of people in their daily lives. Landscapes and nostalgia went out of style.

Paul Grimm (1892-1974) was one of a few artists who continued to paint in a visually representational style. Born in South America, he came to America with his family in 1899 and settled in Rochester, New York. At the age of eighteen, he won an art scholarship to study at the Royal Academy in Dusseldorf, Germany.

He came to California in 1919 and resided in Hollywood. There he supported himself by doing design and advertising work. Grimm was one of the earliest scenic artist for the fledgling Hollywood studios. Unfortunately, his work, painting backdrops for countless silent movies, was never credited and has gone unrecognized. He moved to Palm Springs in 1932 and remained there for the rest of his life.

After he settled in Palm Springs, he became the most eminent of the California desert painters. He won early popular fame, and his studio-gallery became a familiar stop for residents and tourists. President Dwight D. Eisenhower was one of his best known patrons.

Above:
Arthur G. Rider painting in Mission San Juan Capistrano, c. 1928. Photo courtesy of Robert McChesney Bethea.

Opposite:
Arthur G. Rider
Capistrano Ruins, 1930
Oil on canvas
34¼ x 30 inches
The Laguna Art Museum,
Gift of Mr. Robert
McChesney Bethea

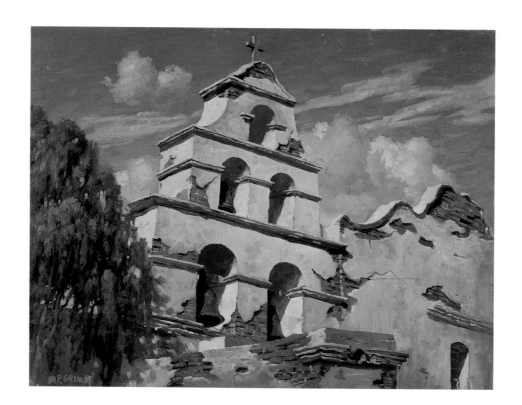

Paul Grimm
Bell Tower, San Diego Mission
Oil on board
18 x 24 inches
Joan Irvine Smith Fine Arts

Edwin Deakin
San Diego Mission
Oil on canvas
15½ x 18¼ inches
Maxwell Galleries,
San Francisco

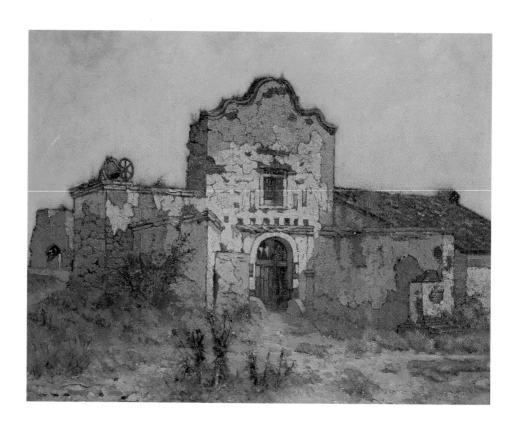

San Diego Mission, painted about 1950, shows the first California mission essentially as it looks today. Compare Grimm's view with Edwin Deakin's painting of the same mission, done sometime in the late 1890s. The mission underwent restoration in 1931. The most striking feature, the bell wall with five hanging bells, had completely collapsed, and the heavy bells were scattered throughout the area.

Queen of the Missions is, of course, the Mission Santa Barbara, one of the most visited of all missions. Grimm, in a direct, realistic style, illustrates the mission as it looks today.

With the passing of time and the changing of tastes, plein-air painting has once again attained popularity in American art. Now in the last decade of the twentieth century, nearly a hundred years after the style originated, the California missions are once again finding favor among artists, collectors and museums.

Over the past half century, California has confirmed its considerable interest in the preservation and restoration of its historic missions. Great efforts have been made to restore these historic sites, and more endeavors are needed to complete the task. In spite of all that has been done, the ever-present menace of earthquakes, the single most prevalent agent of destruction, is still the greatest threat. These paintings captivate the attention of a public interested in preservation and render a substantial service by demonstrating the worthiness of their cause.

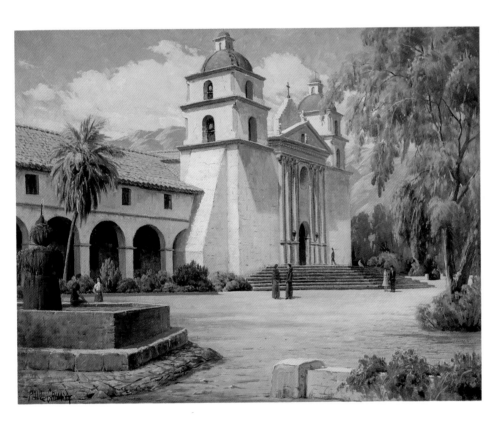

Paul Grimm
Above: San Diego Mission
Pencil drawing
Joan Irvine Smith Fine Arts
Left: Queen of the Missions,
Santa Barbara
Oil on canvas
28 x 36 inches
Joan Irvine Smith Fine Arts

Selected Bibliography

Anderson, Susan M. *Regionalism: The California View, Water-colors, 1929-1945*, exhibition catalogue. Santa Barbara: Santa Barbara Museum of Art, 1988.

Anderson, Thomas R., and Bruce A. Kamerling. *Sunlight and Shadow: The Art of Alfred B. Mitchell, 1888-1972*, exhibition catalogue. San Diego: San Diego Historical Society, 1988.

Art of California. San Francisco: R. L. Bernier Publisher, 1916. Reprinted by Westphal Publishing, Irvine, California.

Baigell, Matthew. *The American Scene: American Painting of the 1930s*. New York: Praeger Publishers, 1974.

Baird, Joseph Armstrong, Jr., ed. *From Exposition to Exposition: Progressive and Conservative Northern California Painting, 1915-1939*, exhibition catalogue. Sacramento: Crocker Art Museum, 1981.

Brinton, Christian. *Impressions of the Art at the Panama-Pacific Exposition*. New York: John Lane Co., 1916.

Brother Cornelius, F.S.C., *Keith: Old Master of California*. New York: G. P. Putnam's Sons, 1942.

Cahill, Holger. *American Art Today, New York World's Fair*. New York: National Art Society, 1939.

California Design 1910. Pasadena: California Design Publications, 1974.

California Grandeur and Genre: From the Collection of James L. Coran and Walter A. Nelson-Rees, exhibition catalogue. Palm Springs, California: Palm Springs Desert Museum, 1991.

Carl Oscar Borg: A Niche in Time, exhibition catalogue. Palm Springs: Palm Springs Desert Museum, 1990.

Coen, Rena Neumann. *The Paynes, Edgar and Elsie: American Artists*. Minneapolis: Payne Studios, Inc., 1988.

Color and Impressions: The Early Work of E. Charlton Fortune, exhibition catalogue. Monterey, California: Monterey Peninsula Museum of Art, 1990.

Dominik, Janet Blake. *Early Artists in Laguna Beach: The Impressionists*, exhibition catalogue. Laguna Beach, California: Laguna Art Museum, 1986.

Falk, Peter Hastings. *Who Was Who in American Art*. Madison, Connecticut: Sound View Press, 1985.

Gerdts, William H. *American Impressionism*. New York: Abbeville Press, Publishers, 1984.

_____. *American Impressionism*, exhibition catalogue. Seattle: the Henry Art Gallery, 1980.

Granville Redmond, exhibition catalogue. Oakland: The Oakland Museum, 1988.

Hailey, Gene, ed. *Abstract from California Art Research: Monographs*. W.P.A. Project 2874, O.P. 65-3-3632. 20 vols. San Francisco: Works Progress Administration, 1937.

Hatfield, Dalzell. *Millard Sheets*. Los Angeles and New York: Dalzell Hatfield, 1935.

Hughes, Edan Milton. *Artists in California: 1786-1940*. 2nd ed. San Francisco: Hughes Publishing, 1989.

Impressionism: The California View, exhibition catalogue. Oakland: the Oakland Museum, 1981

Keyes, Donald D. *American Impressionism in Georgia Collections*. Athens, Georgia: Georgia Museum of Art, University of Georgia, 1993.

Laird, Helen. *Carl Oscar Borg and the Magic Region*. Layton, Utah: Gibbs M. Smith, Inc., Peregrine Smith Books, 1986.

Lovoos, Janice, and Edmund F. Penney. *Millard Sheets: One-Man Renaissance*. Flagstaff, Arizona: Northland Press, 1984.

Lovoos, Janice, and Gordon T. McClelland. *Phil Dike*. Beverly Hills, California: Hillcrest Press, Inc., 1988.

McClelland, Gordon T., and Jay T. Last. *The California Style: California Watercolor Artists. 1929-1955*. Beverly Hills: Hillcrest Press, Inc., 1985.

Millier, Arthur. "Growth of Art in California." In *Land of Homes* by Frank J. Taylor. Los Angeles: Powell Publishing Company, 1929.

Moure, Nancy Dustin Wall. *Artists' Clubs and Exhibitions in Los Angeles Before 1930*. Los Angeles: Privately Printed, 1974.

_____. *The California Water Color Society: Prize Winners, 1931-1954: Index to Exhibitions, 1921 - 1954*. Los Angeles: Privately Printed, 1973.

_____. *Dictionary of Art and Artists in Southern California Before 1930*. Los Angeles: Privately Printed, 1975.

_____. *Loners, Mavericks and Dreamers: Art in Los Angeles Before 1900*, exhibition catalogue. Laguna Beach, California: Laguna Art Museum, 1994.

_____. *Painting and Sculpture in Los Angeles: 1900-1945*, exhibition catalogue. Los Angeles: Los Angeles County Museum of Art, 1980.

_____. *Southern California Artists: 1890-1940*, exhibition catalogue. Introduction by Carl Dentzel. Laguna Beach, California: the Laguna Beach Museum of Art, 1979.

_____. *William Wendt, 1865-1946*, exhibition catalogue Laguna Beach, California: Laguna Beach Museum of Art, 1977.

Nelson-Rees, Walter A. *Albert Thomas DeRome, 1885-1959.* Oakland: WIM, 1988.

Nochlin, Linda. *Realism.* New York: Penguin Books, 1971.

Orr-Cahall, Christina. *The Art of California: Selected Works of the Oakland Museum.* Oakland: The Oakland Museum Art Department, 1984.

Perine, Robert. *Chouinard: An Art Vision Betrayed.* Encinitas, California: Artra Publishing, Inc., 1985.

Petersen, Martin E. *Second Nature: Four Early San Diego Landscape Painters*, exhibition catalogue. San Diego: San Diego Museums of Art and Prestel-Verlag, Munich, 1991.

Stern, Jean. *Alson S. Clark.* Los Angeles: Petersen Publishing Co., 1983.

_____. *Masterworks of California Impressionism: The FFCA, Morton H. Fleischer Collection.* Phoenix: FFCA Publishing Company, 1986.

_____. *The Paintings of Franz A. Bischoff.* Los Angeles: Petersen Publishing Co., 1980.

_____. *The Paintings of Sam Hyde Harris.* Los Angeles: Petersen Publishing Co., 1980.

_____. *Palette of Light: California Paintings from The Irvine Museum*, exhibition catalogue. Irvine, California: The Irvine Museum, 1995.

Stern, Jean, and Janet Blake Dominik, and Harvey L. Jones. *Selections from The Irvine Museum*, exhibition catalogue. Irvine, California: The Irvine Museum, 1993.

Stern, Jean, and Joan Irvine Smith. *Reflections of California: The Athalie Richardson Irvine Clarke Memorial Exhibition*, exhibition catalogue. Irvine, California: The Irvine Museum, 1994.

Tonalism: An American Experience. New York: Grand Central Art Galleries Art Education Association, 1982.

Trenton, Patricia, and William H. Gerdts. *California Light 1900-1930*, exhibition catalogue. Laguna Beach, California: Laguna Art Museum, 1990.

Vincent, Stephen, ed. *O California!: Nineteenth and Early Twentieth Century California Landscapes and Observations.* San Francisco: Bedford Arts, Publishers, 1990.

Westphal, Ruth Lilly. *Plein Air Painters of California: The North.* Irvine, California: Westphal Publishing, 1986.

_____. *Plein Air Painters of California: The Southland.* Irvine, California: Westphal Publishing, 1982.

Westphal, Ruth Lilly, and Janet Blake Dominik, eds. *American Scene Painting: California, 1930s and 1940s.* Irvine, California: Westphal Publishing, 1991.

The Irvine Museum

Romance of the Bells: The California Missions in Art *was edited by David Parry. Paintings reproduced in this catalogue were photographed by Casey Brown and Christopher Bliss. The book was designed by Lilli Colton. Type was composed in Cochin, with Post Antigua headlines. 20,000 soft-cover and 5000 case bound copies were lithographed in Hong Kong through Overseas Printing Corporation. Production was coordinated by Lilli Colton. This is the first edition.*